PORTUGAL

EVERGREEN is an imprint of Benedikt Taschen Verlag GmbH

© for this edition: 1999 Benedikt Taschen Verlag GmbH
Hohenzollernring 53, D–50672 Köln
© 1998 Editions du Chêne – Hachette Livre – Le Portugal
Under the direction of Michel Buntz – Hoa Qui Photographic Agency
Text: Hugues Demeude
Photographs: Thierry Perrin/Hoa Qui
(except: Wojtek Buss: pages 8, 9, 24, 25, 28, 29 (bottom), 30, 31, 32, 33, 35, 42, 43, 52 (top), 63, 66, 67, 69 (right),
70, 71, 72, 73, 75 (top), 91, 94, 95 (right), 105 (top), 108, 109, 118; Philippe Body: pages 152, 153;
T. Borredon: pages 16, 53; De St Ange: pages 80, 81, 84; P. Frilet: page 106; M. Garnier: pages 93, 123;
Gilles Guittard: pages 64 (horiz.), 144; ISIP: page 26 (top); Robert Leslie: page 34;
Jean-Michel Roignant: pages 102, 103; Stockshooter: page 37; N. Thibaut: page 150.
Photographs supplied by the Hoa Qui Photographic Agency.)
Map and illustrations: Jean-Michel Kirsch
Editor: Corinne Fossey
Cover design: Angelika Taschen, Cologne
Translated by Ian West
In association with First Edition Translations Ltd, Cambridge
Realisation of the English edition by First Edition Translations Ltd, Cambridge

Printed in Italy
ISBN 3-8228-7065-X

PORTUGAL

Text HUGUES DEMEUDE

Photographs THIERRY PERRIN

EVERGREEN

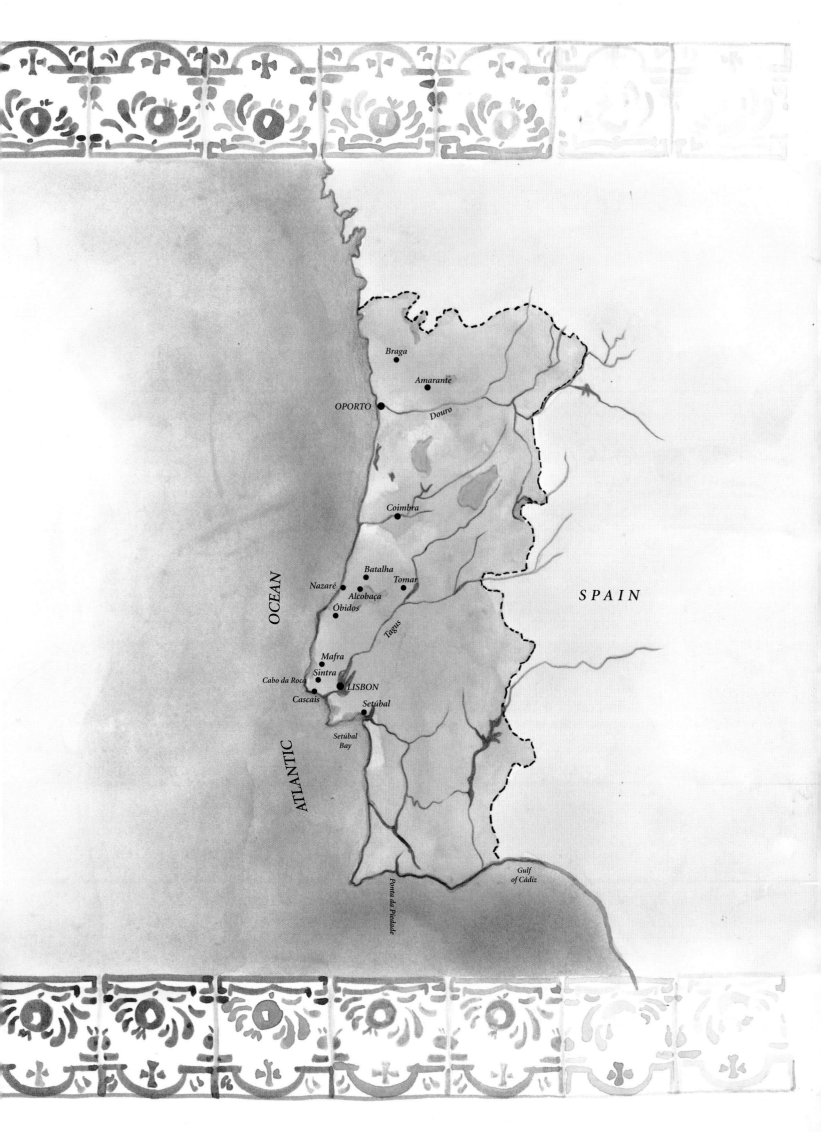

Birthplace of explorers and poets, busy town-dwellers and country folk close to the soil, Portugal is small in extent, but has left a lasting impression on the history of mankind.

The country is roughly rectangular in shape with an area of scarcely 100,000 km² (39,000 sq miles). Before the era of the great discoveries, the Portuguese found themselves trapped between their powerful neighbour Castile, always on the lookout for new territory, and the impassable barrier of the ocean. Beyond this ocean nothing was thought to exist – except perhaps a world full of terrifying monsters. But, in the fifteenth century, exploiting their window onto the Atlantic, the Portuguese acquired the means to head for those new horizons, which would seal their destiny and guarantee their fortune. First Africa, then the Indies, the Far East and South America were discovered by Portuguese navigators during that long series of voyages which brought home not only wealth and glory but the leaven of new civilizations. In *The Lusiads*, his great epic poem of the late sixteenth century, the celebrated Portuguese poet Luís de Camões recreates the incredible voyage of Vasco da Gama (begun in 1497), masterfully describing how da Gama enriched the Old World with his discovery of the New, and revealed to mankind an entirely fresh vision of the future.

The year preceding the World Exposition in Lisbon – Expo'98 – was one busy with commemorations evoking both the country's former glory and the roots of its national identity. The Exposition, whose theme was 'The Oceans, a Heritage for the Future', was centred around the the 500th anniversary of Vasco da Gama's epic voyage to India. 1997 was also the 850th anniversary of the retaking of Lisbon from the Moors by the young king Afonso Henriques on 25 October 1147. The first monarch of an emergent Portugal,

Afonso laid the foundations for its national independence. Now regarded as the country's founding father, he was the son of Henry of Burgundy and Tareja – daughter of Alfonso VI of Castile and Léon. All in all, Portugal experienced the rule of four dynasties: the Houses of Burgundy, Avis, Austria (the three Philips), and finally Bragança. Thirty-four sovereigns in turn held the sceptre of this little country with its wealth of resources before, in 1910, a coup d'état drove the young Manuel II into exile and a Republic was proclaimed.

Each of these dynasties contributed to the enrichment of the kingdom with a proliferation of monuments that were sensational examples of their type, whether churches consecrated to the glory of a Deity held in the greatest reverence, or palaces having to satisfy the tastes of a refined and demanding Court. The old cathedrals of Lisbon and Coimbra, which had inspired the same dizzying sensations of power and majesty since the twelfth century; the monastery at Alcobaça symbolising, in a single work of art, the national spirit of independence; the Convento de Cristo at Tomar, still breathing the spirit of the Templars: all are extraordinary architectural tours-de-force reflecting the high pitch of spiritual devotion and the deep piety of an entire people.

The Palácio de Queluz was inspired by Versailles. Sintra was the official summer residence of the kings of Portugal till the end of the sixteenth century. Pena gloriously juxtaposes a Gothic keep with Arab minarets, Manueline windows and cloisters, and Renaissance altarpiece. All these are the living traces of a highly refined society with a disciplined sense of luxury. The baroque style, which originated and developed in the eighteenth century, is typically Portuguese, flourishing from this era onwards through architecture and the decorative arts.

Overleaf:
Fine seigneurial mansion in Lisbon.

After nine centuries of fierce independence, and having established its national identity on the basis of common values and a language of crystalline purity, Portugal is today held up as a model of economic and social transformation, dynamic and modern in its outlook. Within this model its protagonists proudly strive to combine the advantages of economic growth with respect for deep-rooted traditional values inherent in family life, work and relationships. This individualism which characterizes the Portuguese must be understood in the context of their geographical position and the landscape. Though the sea has always been their destiny, their territory is far from being one long shoreline, even if the large towns of the Atlantic seaboard have often developed to the detriment of population levels in the rural areas.

Three basic climatic zones determine the nature of the landscape and vegetation: continental in the north-east, Atlantic in the northwest and Mediterranean in the south. Within these boundaries the Portuguese gradually colonized the hills and valleys, creating new homelands, and disseminating their own blend of practical wisdom and complex values. One can travel the length of the country, through Trás-os-Montes and the Minho in the north, the Beiras in the centre, onward via the Ribatejo or Estremadura, over the great River Tagus and the Alentejo, down to the Algarve in the extreme south: always one will find that the language spoken is the same Portuguese, but the bearing, the aspirations and the lifestyles of the people inevitably reflect the lands which nurtured them. Yet an obvious inner strength tinged with a certain nobility unites the whole people, townspeople and country-folk alike. They cannot fail to disarm the visitor and arouse a sense of empathy. Portugal itself is just as quick to conquer the heart.

Opposite: A famous azulejo from Pinhão railway station.

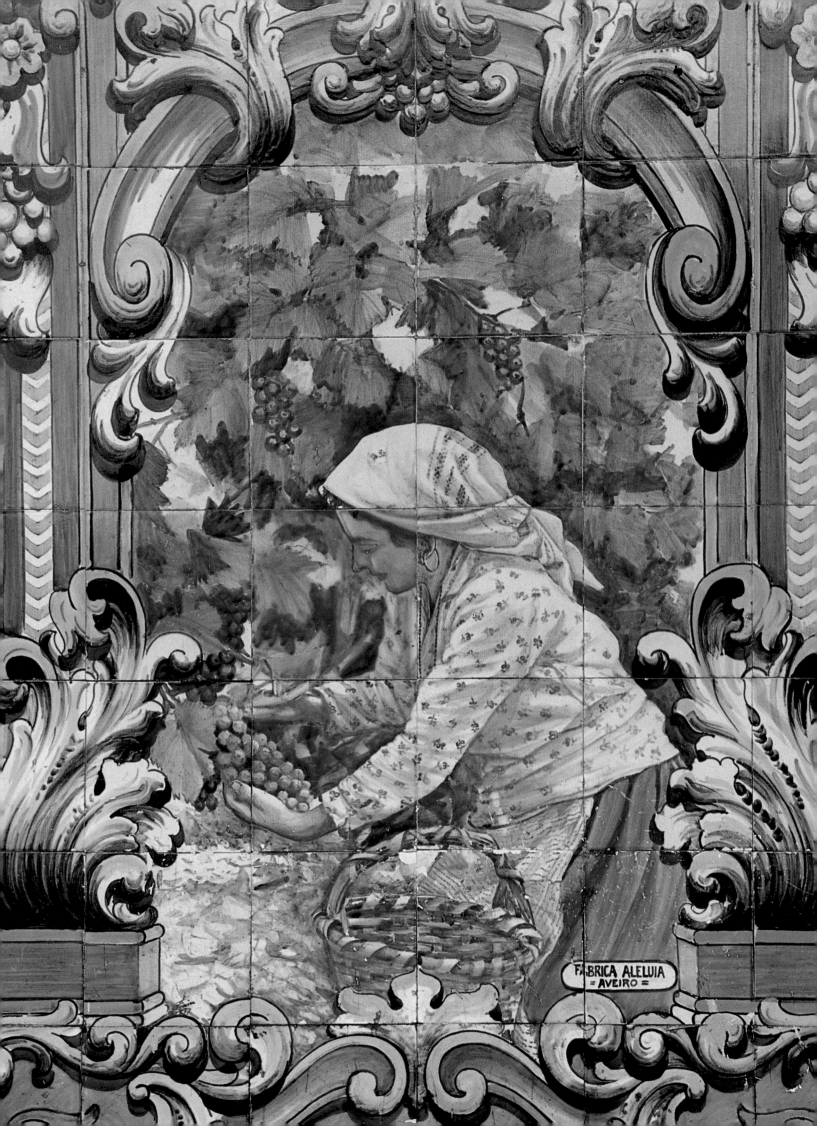

FABRICA ALELUIA
= AVEIRO =

LISBON

Standing on a wide strip of land where the great River Tagus flows into the sea, Lisbon has never ceased to expand, infiltrating the hillsides ranging from gentle slopes to sheer cliffs.

Opposite: In the old quarter of the Alfama, the facade of this apartment block evokes a whole world of images. Formerly the popular fishermen's district, the area still contains a large number of houses whose architecture, peeling walls, ironwork, and lines of washing lend them a particular charm.
Overleaf: One of the vistas from the Santa Justa lift. In the foreground can be seen the neat layout of the Lower Town – the Baixa – reconstructed in chequerboard fashion after the 1755 earthquake. In the background, the Castelo de São Jorge is enthroned on its hill, surrounded by green trees and its crenellated walls.

Seven major hills form the contours to which the city clings. Each of the traditional quarters has developed its own history, its own ways and lifestyle, all still essential to the capital's cultural identity. The Alfama is the old fishing district. Its buildings extend in a broad panorama over a hillside criss-crossed by an intricate network of alleyways and gaze down on the Tagus below. Here the echoes of the wind drift up, intermingled with snatches of timeless human sounds. The Baixa, or Lower Town, has been for a century and a half the fashionable and wealthy commercial area. Its three great parallel arteries, stretching from the Rossio to the huge and famous Praça do Comércio, were rebuilt after the terrible earthquake of 1755. The Chiado, starting at the Rua Garrett, is based around a series of elegant and solid buildings testifying to the turbulence of centuries past and the restless creativity of modern times. Today it is striving to regain its prestige after a devastating fire in 1988 which destroyed several fine structures regarded as symbolic of the district's character. The Upper Town or Bairro Alto has taken shape in a quaint and haphazard manner. Its framework is a labyrinth of small, cobbled streets, perfect for a wander or a longer exploration beneath the facades of houses three or four storeys high, all huddled and jostling together.

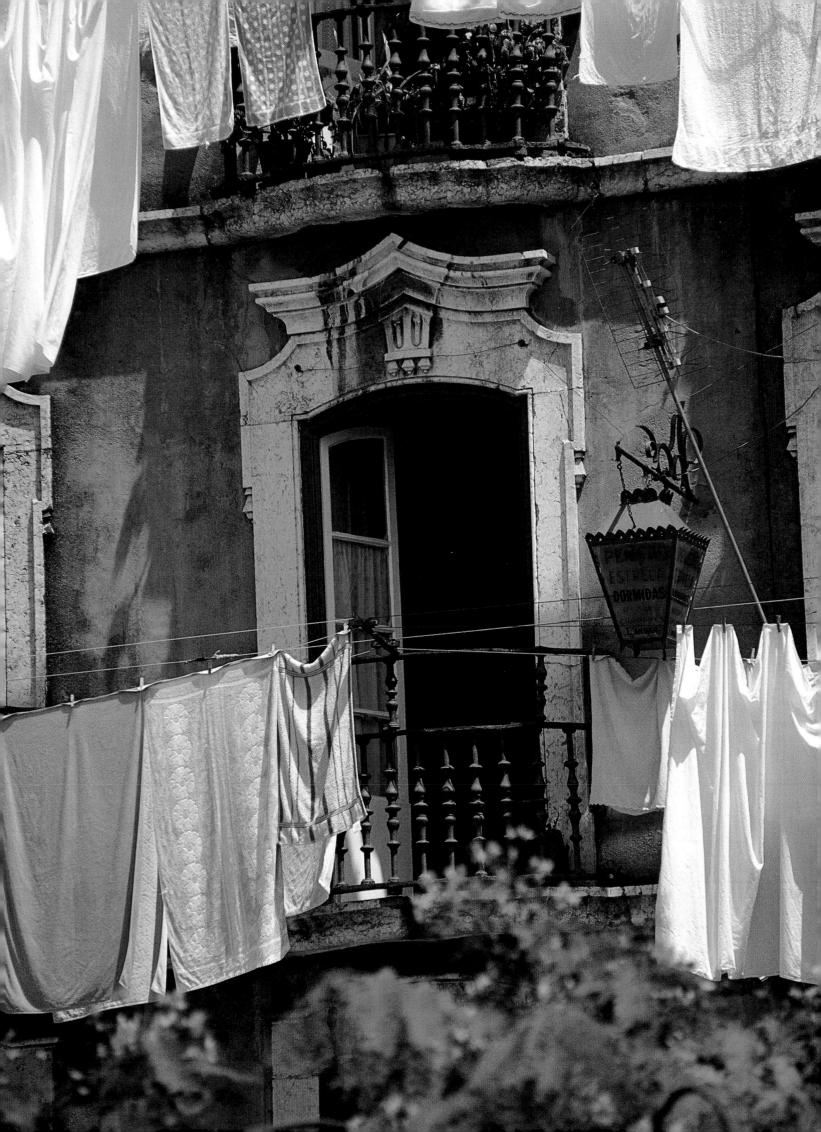

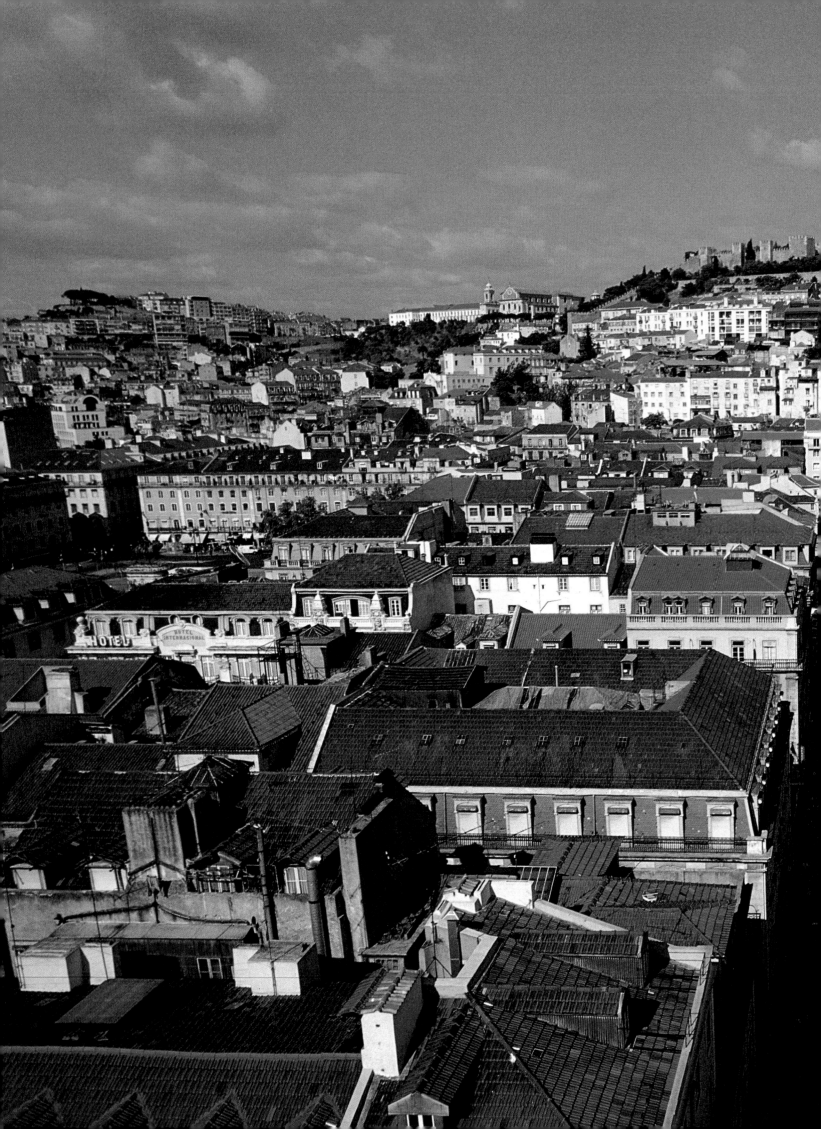

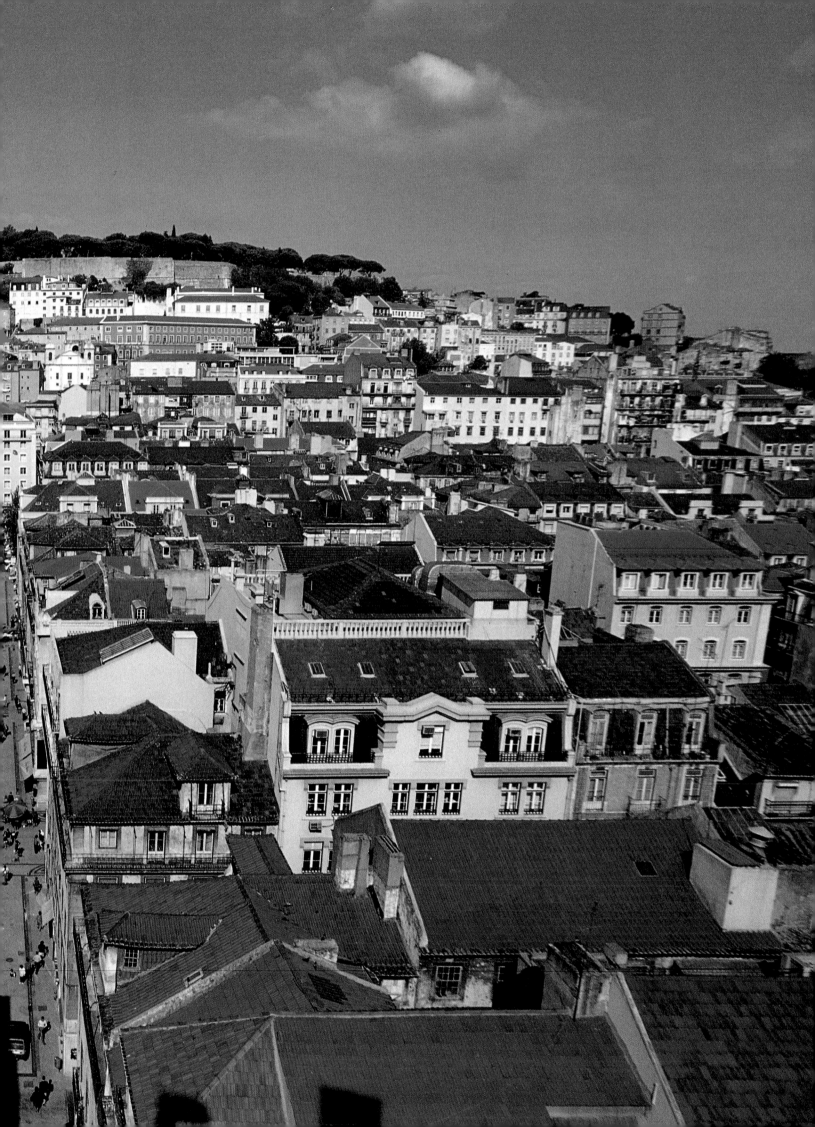

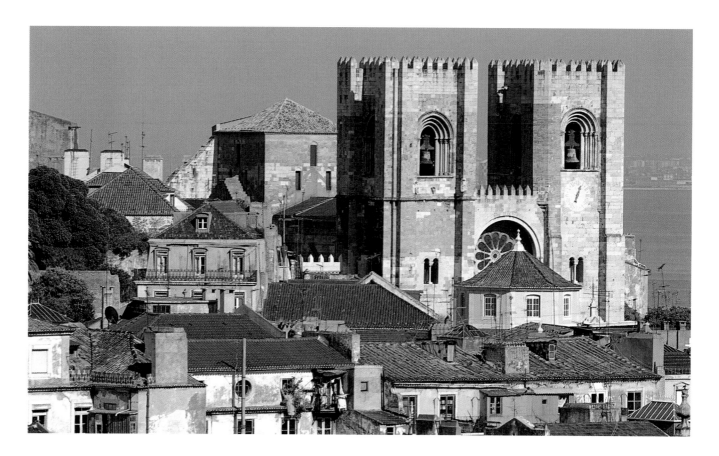

*A*bove: *Lisbon's cathedral – the Sé – was constructed immediately after the recapture of the city from the Moors by the first Portuguese king Afonso Henriques in 1147. Its front gives an appearance of massive strength, like the battlements of a fortress.*

Most of these façades, bearing the marks of time, are adorned with balconies of fine ironwork, while on rainy days the white and grey stones below are bathed in warm light from a scattered array of wall-lanterns. Set apart from the preceding districts and lying beside the Tagus, which was once its natural port, the district of Belém is both near the sea – its celebrated sixteenth-century tower, for instance, seems to be searching the horizon – and yet close to heaven with its majestic Mosteiro dos Jerónimos, dating back to the great voyages of discovery.

Every district has absolutely stunning views over the city. Everywhere, high or low, steep slope or open square, is a potential place to spot landmarks or see the sights from a different aspect. The Castelo de São Jorge commands the heights above the Alfama. Built by the Moors, it was retaken by the first Portuguese king Afonso Henriques in 1147. From way up on this miradouro (vantage point) one's eye is drawn not to the sprawling mass of Lisbon but onwards and outwards, from the farthest modern quarters in the north to where

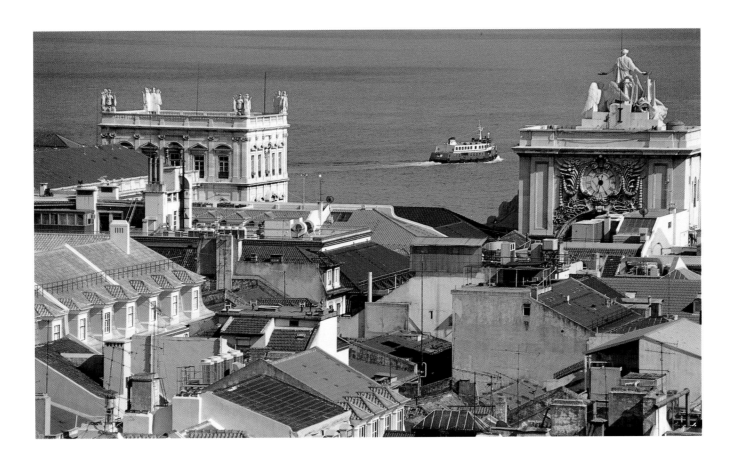

*T*he boat seen between the two towers of the great stone arcade in the Praça do Comércio
is heading for Lisbon's southern bank and the Almada
district, crossing the Tagus where the river is especially wide.

• The Last World Exposition of the Twentieth Century •

Lisbon was the venue for the last world exposition of the twentieth century – Expo'98 – based on the theme *The Oceans, a Heritage for the Future.* It featured festivities and spectacles linked to special events, but most essentially, Expo'98 aimed to publicize the knowledge we have acquired about the oceans, to heighten public awareness of the need to preserve resources, and remind the international communities of their duty to conserve our common heritage for future generations. The exposition also gave Portugal the chance to celebrate the pioneering role it played in the great voyages of discovery of the fifteenth and sixteenth centuries. Expo'98 ran from 22 May to 30 September 1998, playing host to some 145 countries and institutions, and welcoming in the region of 8 million visitors.

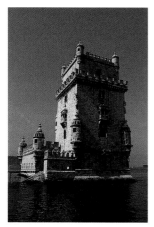

This page and opposite: Pleasure boats and cargo vessels continue, as in the days of the caravels, to salute the elegant Torre de Belém built between 1515 and 1521 at the command of King Manuel I. Through a unique ornamental style allying exuberance and decorative refinement with architectural robustness, it bears testimony to a bygone age of power and prosperity.

the sky and the Tagus meet on the horizon. The view from the Castelo allows the visitor to comprehend the size and extent of the Portuguese capital. But above all, it gives a romantic introduction to Lisbon. Undulating lines of orange-tiled roofs follow the sharp contours, while boats come and go, linking the city's two shores beneath the kindly and watchful presence of a Christ in Majesty modelled on Rio de Janeiro's. Columns of pigeons wheel skyward, and mocking screeches accompany the swirling flights of seagulls. Everything has its role in perpetuating the magic of Lusitania's chief city. In addition, situated between the Baixa and the Chiado, the Santa Justa lift, one of the main attractions in Lisbon's centre for over a century, allows the visitor to ascend right up to the Bairro Alto. Via a walkway, one emerges from the wrought-iron tower onto a terrace offering another uninterrupted viewpoint. This is an ideal place to gain an overall impression of the Praça de Dom Pedro IV, commonly known as the Rossio, one of Lisbon's nerve-centres, where life never stands still.

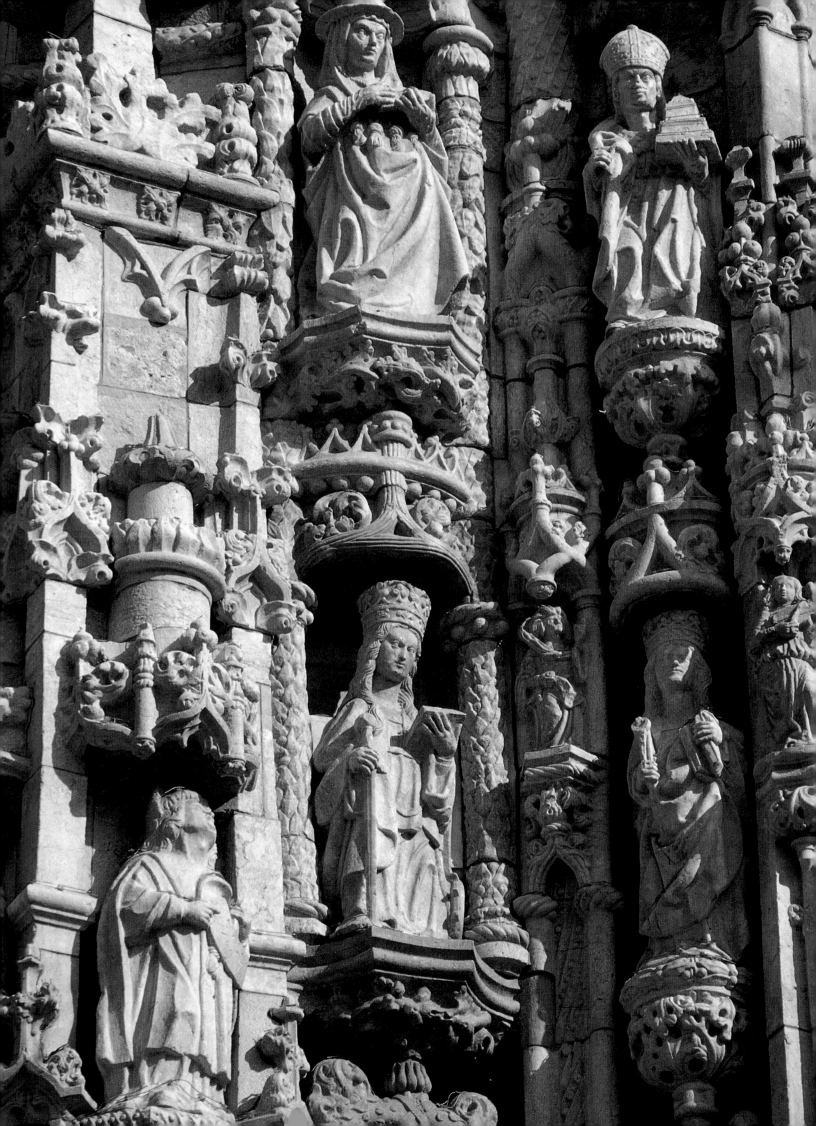

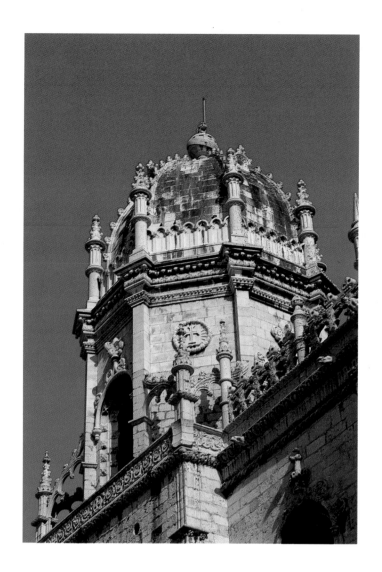

Perched high up on a corner of the hill occupied by the Bairro Alto, and linked to the Baixa and the wide Avenida da Libertade by the Elevador da Glória, the São Pedro de Alcântara Terrace also offers breathtaking views. A few hundred yards away, across the Bairro Alto, we come upon a haven of peace and tranquillity in the shape of the Santa Catarina Gardens. These too are perched on a hilltop, and the vista here takes in part of the quays along the ever-bustling Avenida 24 de Julho, the majestic Tagus with its golden-brown reflections, Lisbon's south bank and the Almada district, as well as the great steel bridge 3,200 metres (3,500 yds) long and rebaptised the Ponte 25 de Abril in homage to the Carnation Revolution of 25 April 1974.

This page and opposite: The Mosteiro dos Jerónimos in Belém was begun in 1502 by King Manuel I on the site of a chapel erected by the Infante Henry the Navigator. The stonework, in the Manueline style, is an unquestioned masterpiece.

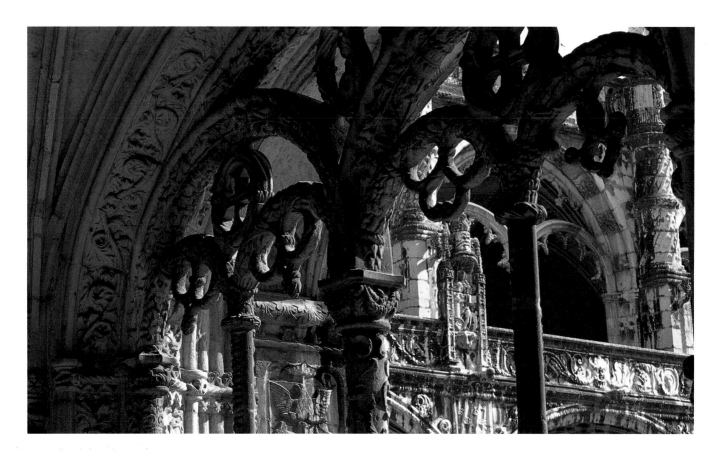

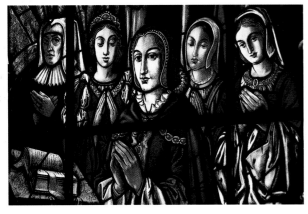

*A*bove: *The stained glass windows lighting the interior of the monastery are of a quite remarkable richness and delicacy.*
Top and overleaf:
The cloisters of the monastery consist of two superimposed galleries with semicircular arches supporting the ribbed vaulting.
Opposite:
Inside, the monastery has three naves separated by six octagonal pillars.

For the visitor exploring Lisbon's historic centre on foot, each of these halts is more than just a moment to take a rest and recover one's breath. There is always something to entice one to walk a little further, despite the fact that each stage can be hard going in this city of hills. This is the best way to soak up the atmosphere and find one's way about. A reward is guaranteed: the sensation – not easily put into words – of being free as a bird, all ties and cares forgotten. Lisbon's sky, for example, whether bright blue and luminous with sunlight or rain-sodden, grey and dull, adds a peculiar intensity to life. The same is true of other features of the old Lusitanian capital, which, like the sky, can make one's heart leap, set emotions racing, and inspire a unique sense of time and place. To take one instance, the 'dragon's teeth' – little cube-shaped paving-stones – have an amazing charm. In the big pedestrian thoroughfares of the Baixa or the alleyways of the old quarters, the arrangement of these white or sometimes grey stones represents a mixture of human ingenuity, a

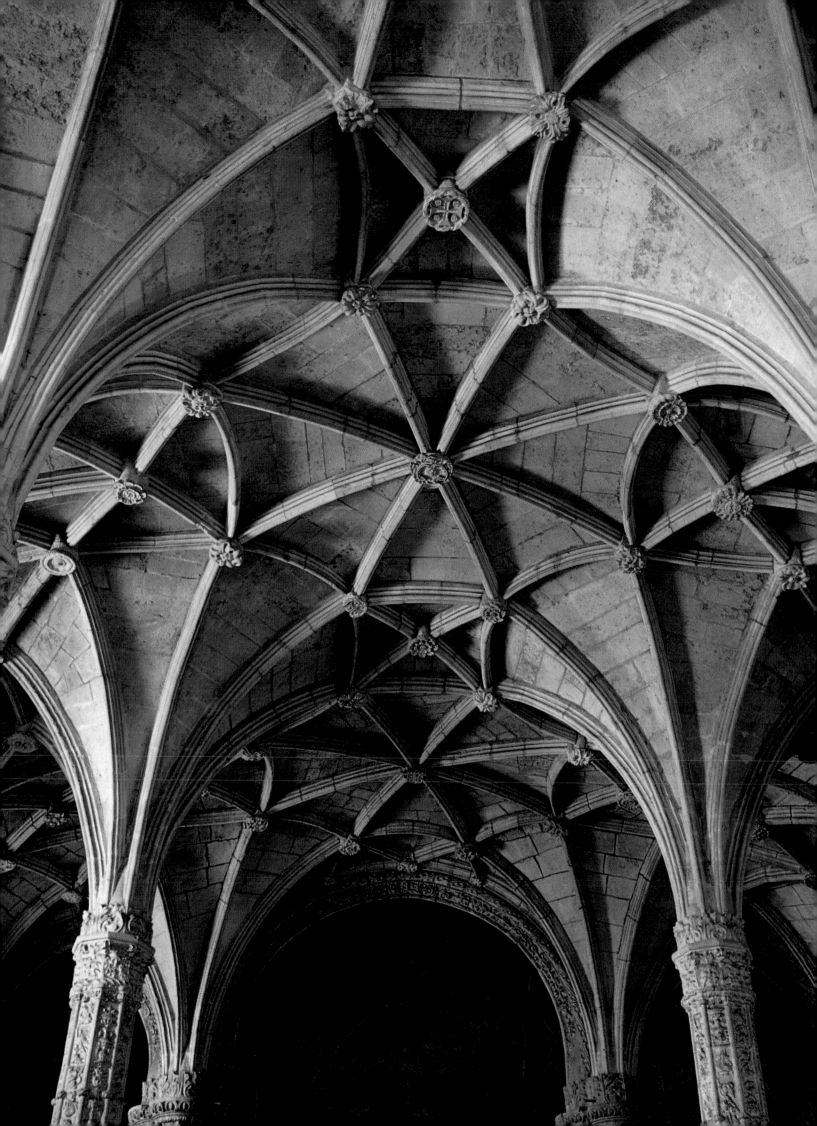

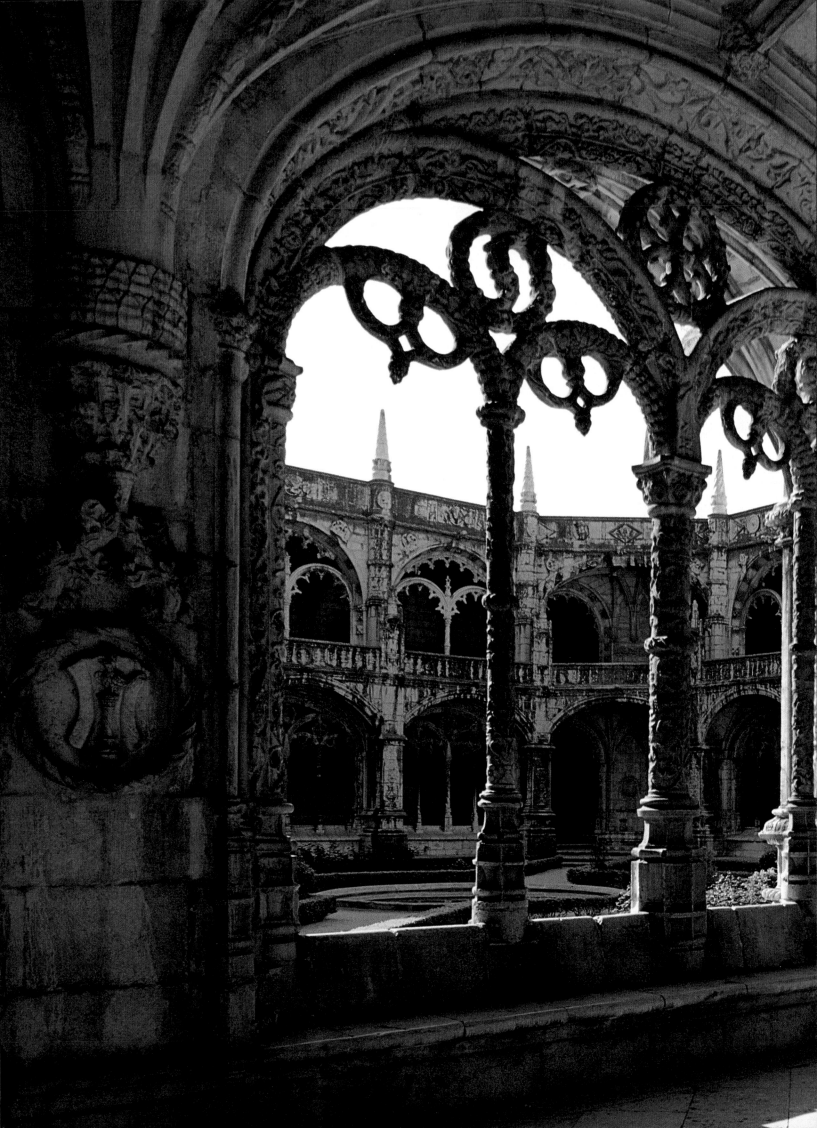

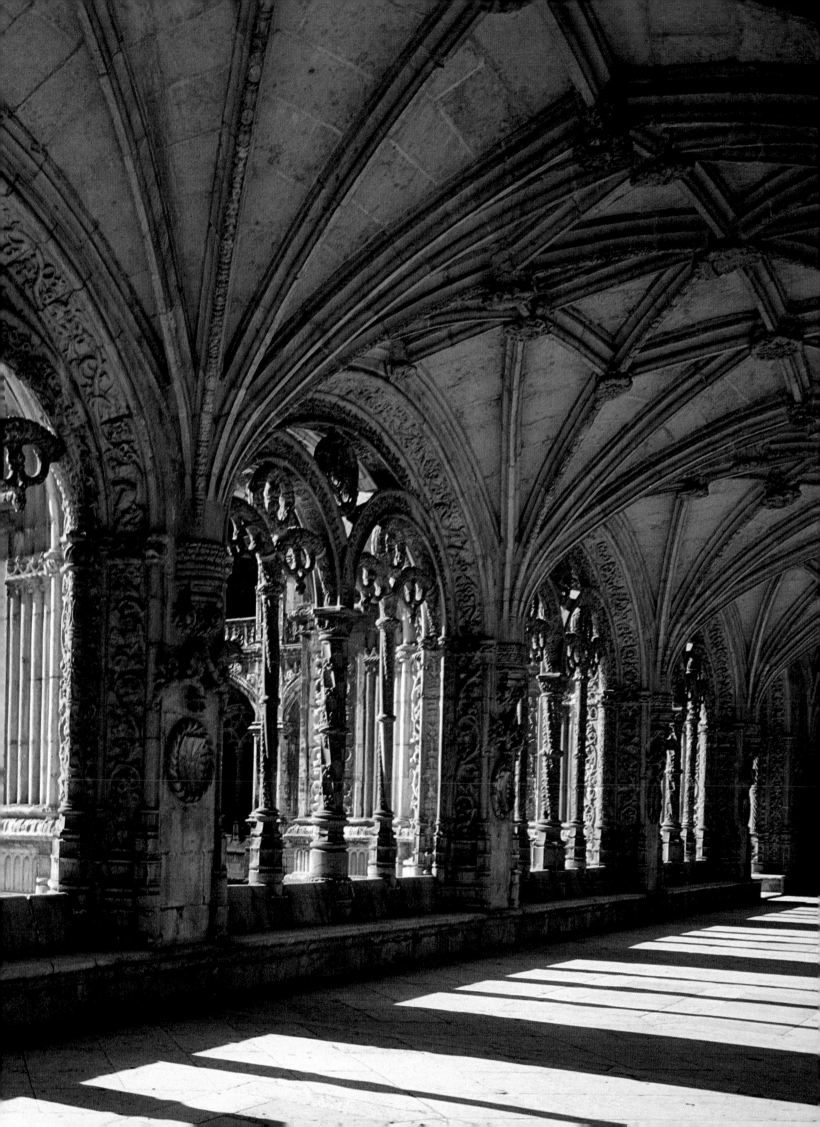

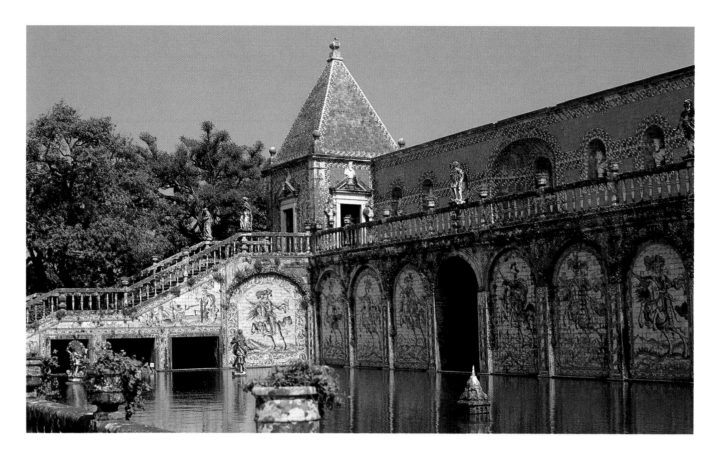

Top and above: 'Azulejos', or ceramic tiles, are most commonly polychrome. Here, however, following the main trend of the eighteenth century, the colours are restricted to blue and white. The 'Azulejos' of the Palácio Fronteira contain frequent depictions of military might and dynastic power.

communal sense of respect for the environment, and a definitive statement of taste. Throughout Portugal, the importance of these stones is unmistakable, paving as they do the majority of the streets and giving each town its individual look. By day, the white stones reflect and scatter a Mediterranean, almost oriental brightness; at night, whenever it rains, the same stones glisten under the light of old-style lanterns.

The monuments of Lisbon, chief among them being its churches, are – like the sky, the 'dragon's teeth' pavements, and the contours – inseparable from the character of the city, even if there are few real jewels amongst them. Lisbon's cathedral, the Sé Patriarcal, ranks amongst the oldest and most famous buildings, dating back directly to the retaking of the city from the Moors by the Portuguese on 25 October 1147. In his guide to Lisbon, the poet Fernando Pessoa recalls the cathedral's great age and the multitude of events it has witnessed, before referring to the particular charm of this building

with the outward appearance of a fortress: "The interior of the Sé deserves a very careful visit. Especially worthy of attention are its three naves, its arcading, its stained glass, the font where St Anthony was said to have been baptized in 1195, the Bartolomeu Joanes Chapel, the terracotta crib by Machado de Castro, and all the paintings waiting to be admired."

Of later construction is the Carmelite church, the Igreja do Carmo, built on the Bairro Alto in the late fourteenth century. Partially destroyed by the 1755 earthquake, it is still capable of arousing an emotional sense of beauty. Its soaring Gothic arches suspended beneath the open sky appear to transcend time, to endure despite the desolation of the supporting ruins. In a different architectural style is the Mosteiro dos Jerónimos in Belém (short for Bethlehem). Begun in 1502, this is architecture at its greatest, highly decorative in conception and a celebrated example of the style known as Manueline, with reference to the reign of Manuel I, remembered as

Above: The Palácio Fronteira is well worth a visit. Built at the end of the seventeenth century as a comfortable residence, it enjoys delightful gardens, the most noteworthy feature of which is the Kings' Gallery, where its twelve ceramic panels depict the twelve kings of Portugal up to João VI in the form of horsemen. The gardens are also used for festivities, relaxation, and various offbeat functions.

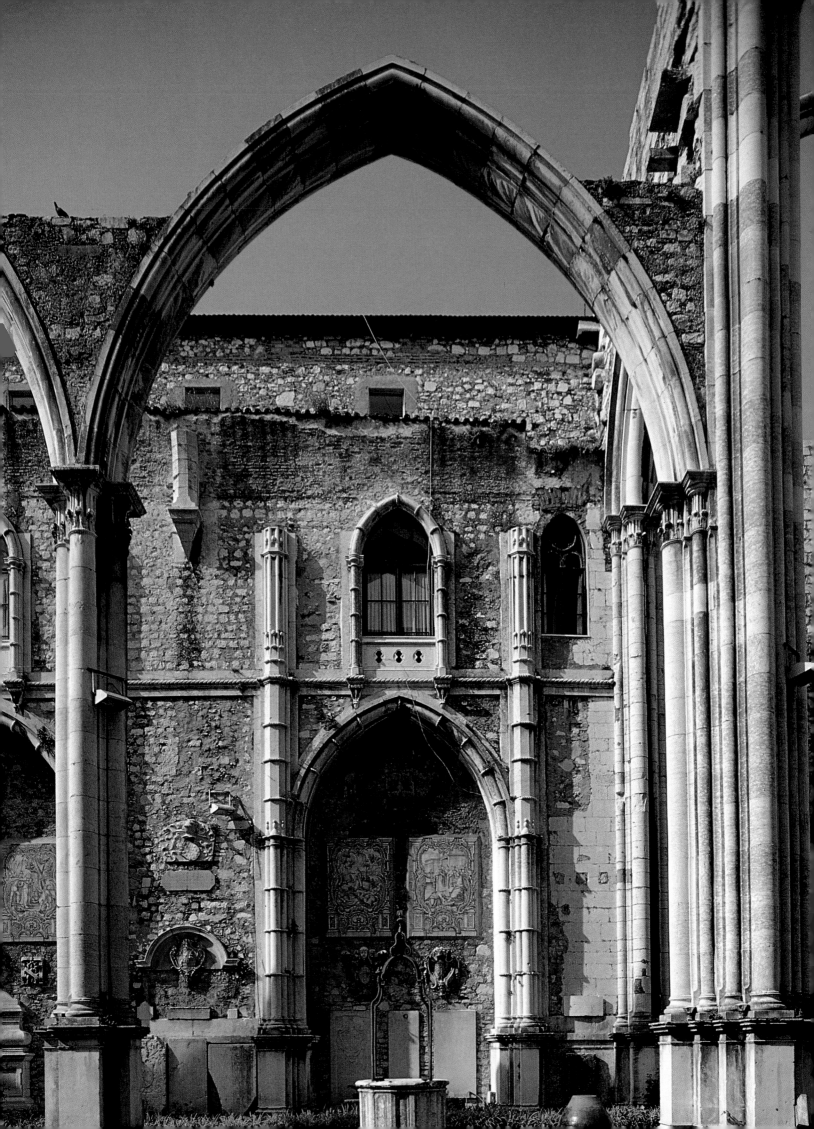

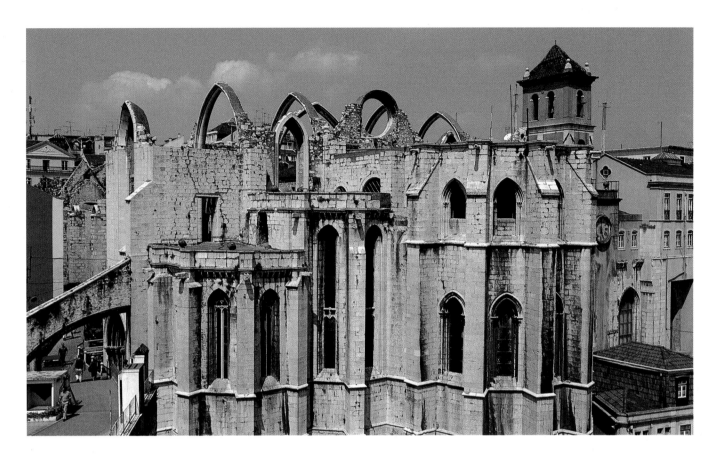

the monarch who presided over the great exploratory voyages. Basically a Gothic structure, the building is adorned with a profusion of naturalistic decoration. Fernando Pessoa is at pains to warn the tourist: "To make the most of Jerónimos, it must be taken in very slowly. Its countless treasures demand meticulous study: every minute detail of its statuary, its tombs, piers, vaulting – especially that of the transept, unsupported by a single pillar – its paintings, the choir, from which one can see almost the entire church, and the cloisters, among the most beautiful in the world…"

Even if they do not match the splendour of these three key monuments to Lisbon's particular development of Christianity, there are many other churches, all in constant use. Here men and women of all ages come for quiet meditation and to offer up prayers, for these great stone monuments are also centres of Christian worship. The Catholic religion continues to mobilize believers; theirs is a devoutness whose roots tend to run very deep. The passage of the morning

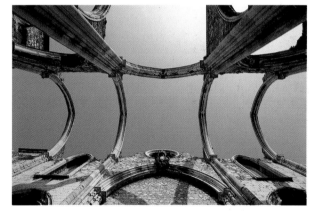

This page and opposite: The Church of the Carmelite Convent – Igreja do Carmo – was a building of perfect beauty before the earthquake of 1755. A living and eloquent vestige of the city's history, its majestic architecture still retains its power. Built between 1389 and 1423, the church now lies with nave and side walls open to the air. But its arches, soaring against the bright blue sky, are as astonishing as ever.

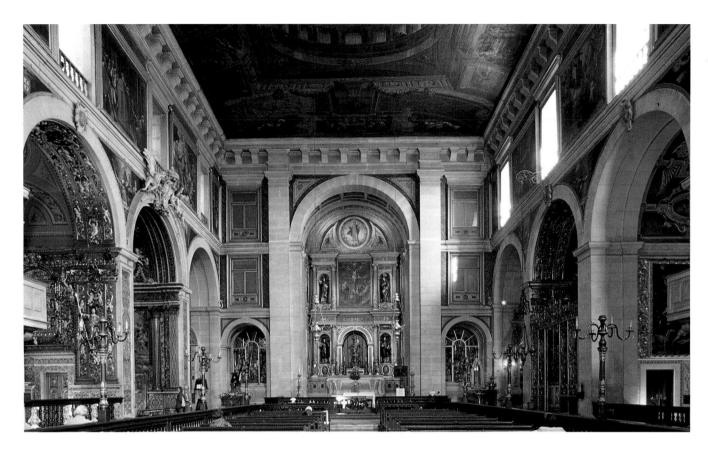

Above and opposite: Portuguese churches are perfect places for silent meditation and reflection, often of great beauty and refinement, as is the case with the Igreja de São Roque.
Overleaf:
On 24 October 1147 the Castelo São Jorge was the scene of an epic battle between Moorish and Portuguese forces. Built on a commanding height, the fortress is still highly prized by the people of Lisbon, both for its historical associations and its role in the urban landscape.

and evening hours is punctuated by the comings and goings of large numbers of Lisboans in search of spiritual nourishment and expression. Representatives of a Christianity now glorious in the shape of the Templars, now dark and sombre under the Inquisition, Lisbon's people remain faithful to the Church that was the bedrock of the Portuguese nation, and their real and enduring fervour sheds its glow upon the whole of society.

The respect for tradition and values connected with the family, work, and relationships is still very apparent. Some characteristics are particularly inescapable. There is self-discipline, for instance, as demonstrated in the lengthy queues for public transport. Resoluteness and endurance are exemplary virtues which parents are at pains to instil in their children, especially the boys. Finally there is that reserve which denotes restraint and sensitivity rather than lack of warmth – and the dignity which appears to have filtered down to all age groups from the older generation. This group

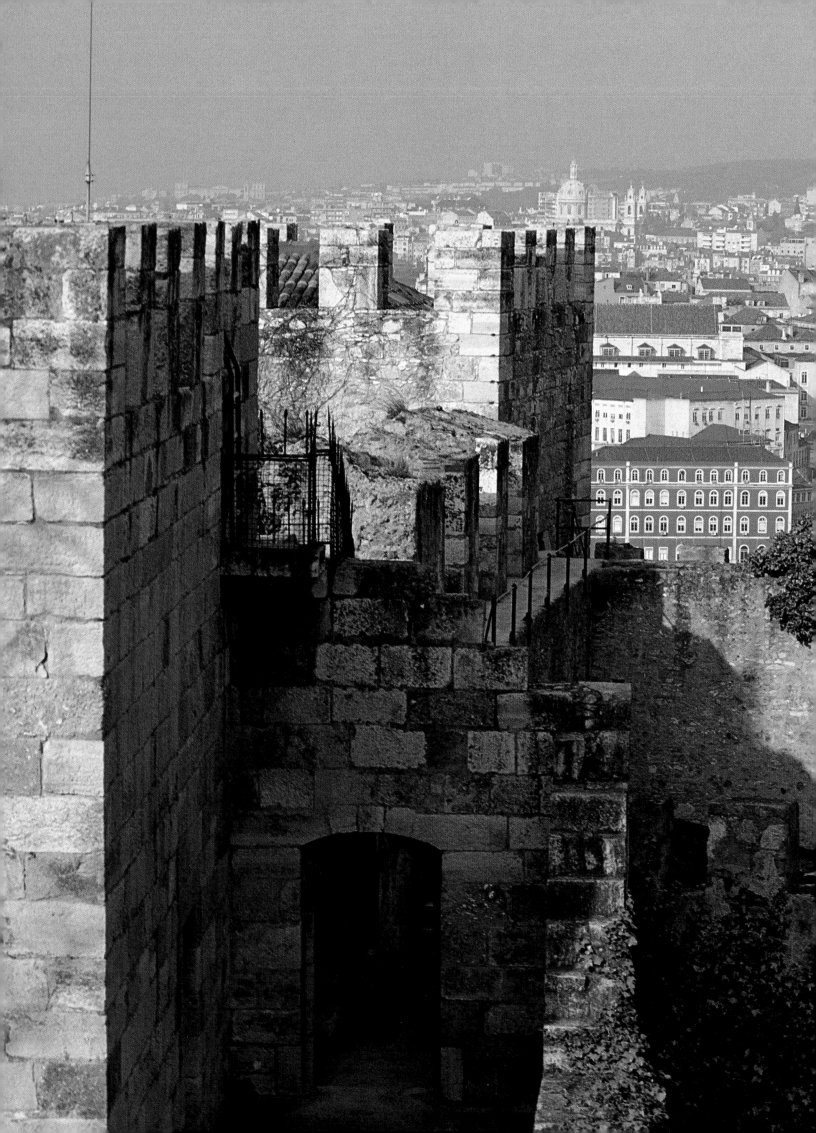

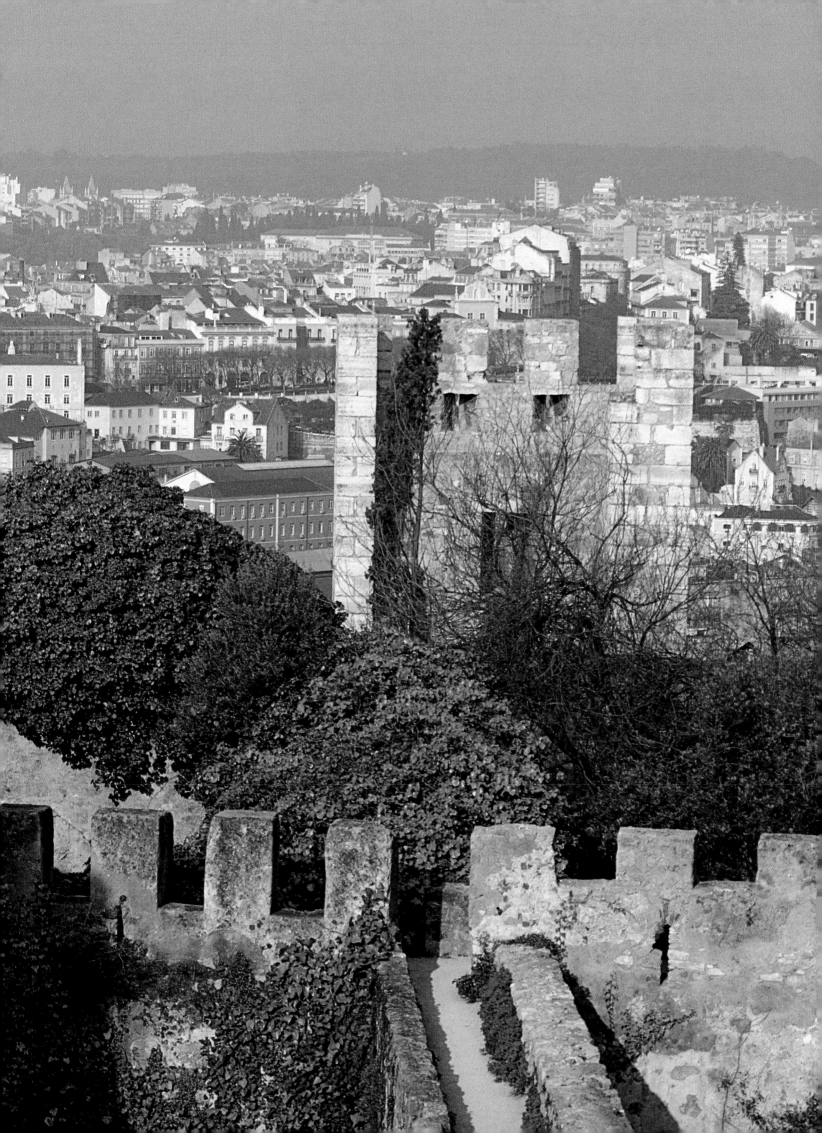

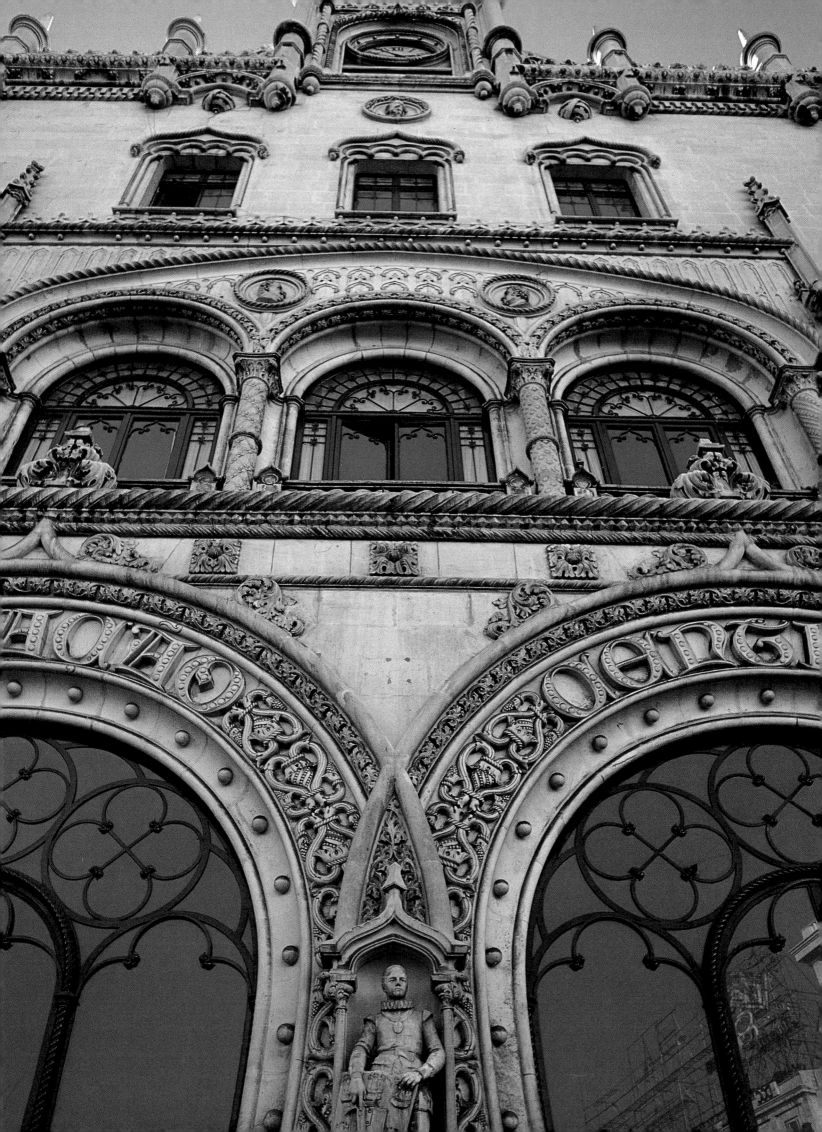

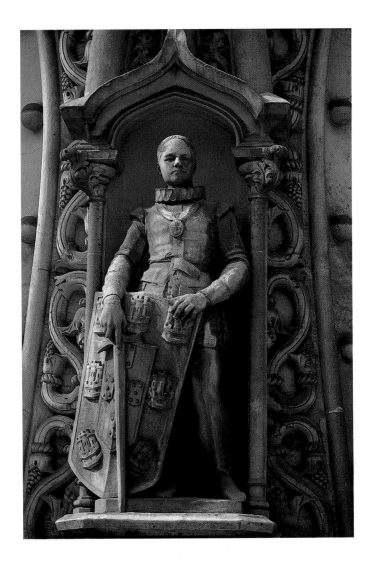

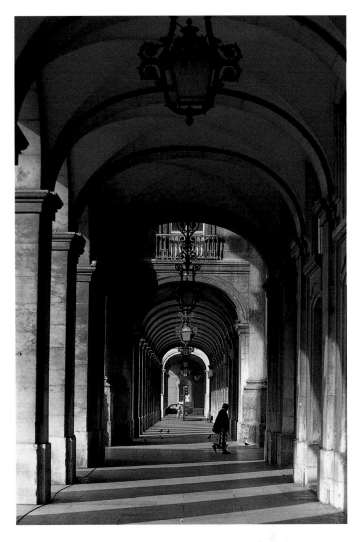

struggles on in the face of all adversity, particularly the disorientation arising from the hectic pace of modern city life. These traits, whether in individual or communal behaviour, appear in the Portuguese character as a singular form of sensitivity, with a high degree of refinement and responsiveness. There is a vivacity in the way the people walk, look at and speak to each other, in the precision of their gestures and their swiftness of comprehension, revealing an intense inner process at work, some mysterious chemistry of the emotions peculiar to Lusitania.

The fado singing heard in some bars in the Bairro Alto represents the shared expression of that extraordinary melancholy haunting the souls of the Lisboans and their city. It is the song of a heart full

Top left and opposite: Very close to the Rossio, Lisbon's central railway station has been one of the city's busiest focal points since 1890. Between the two great horseshoe-shaped glass windows of its neo-Manueline facade, the architect José Luís Monteiro has inserted a statue of Prince Henry the Navigator holding a magnificent sword, and a shield emblazoned with the arms of Portugal.
Top right: Around the huge Praça do Comércio, there are three large, arcaded buildings; one can climb part-way up to enjoy a pleasant and unobstructed walk.

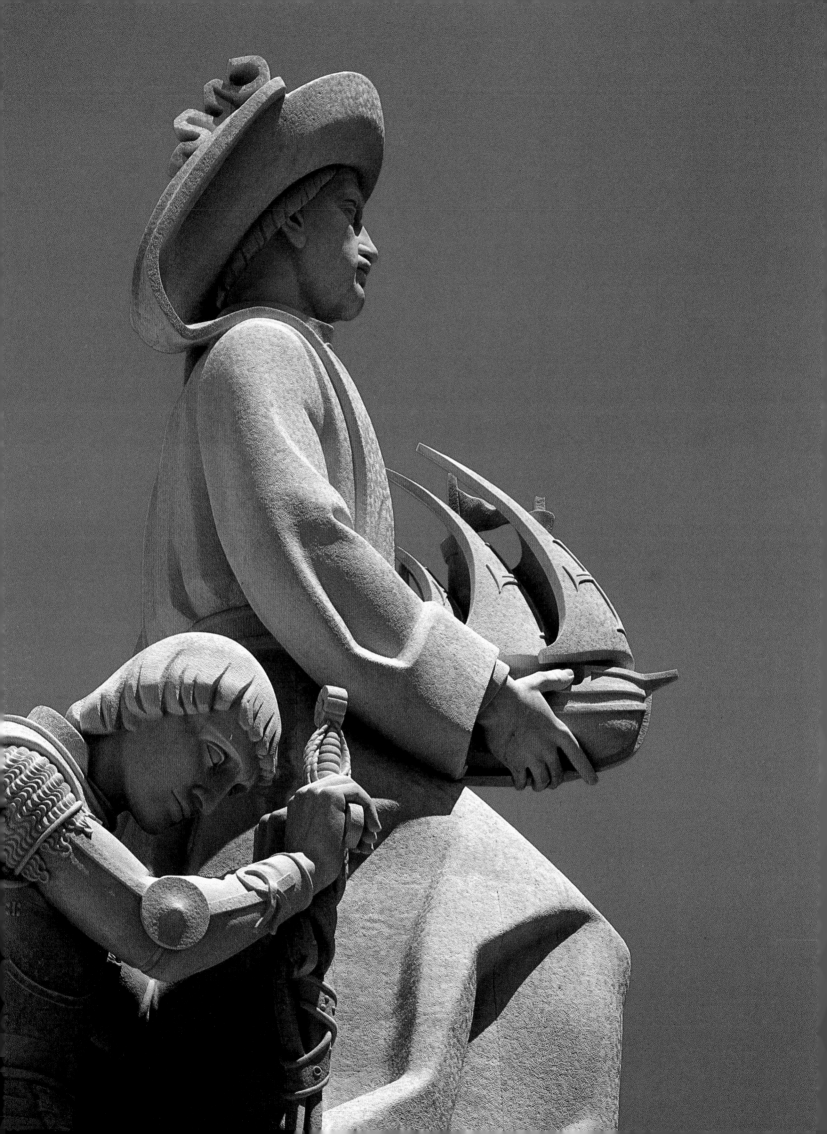

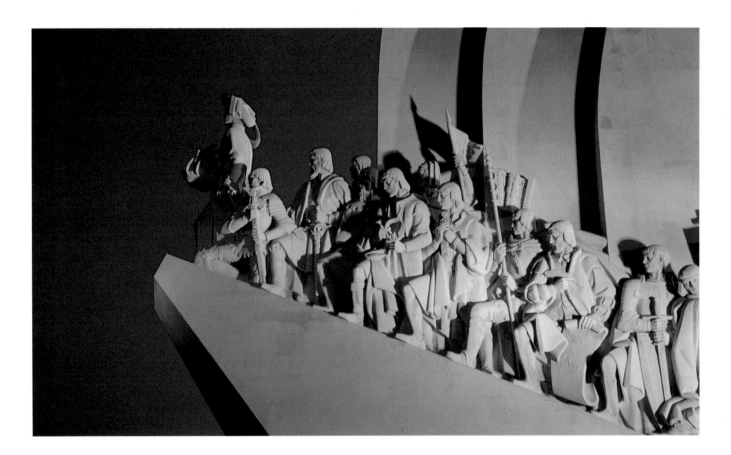

to bursting with life. Something seems to wrench apart when the fadista begins to sing, standing upright, her head thrown back, eyes half-closed, and an expression of passionate and radiant intensity illuminating her face. It is not a cry, as the chant is melodic; but clearly, there is an outpouring of profound inner feelings. The vocal frequencies are syncopated, vibrant, full of human dignity and restrained despair.

The inspiration for the *fado* is *saudade*: a nostalgia unique to the people of Portugal and many Portuguese speakers. It combines a yearning for the past and attachment to Portugal's roots with the sadness occasioned by inevitable exile from home. Today, indeed, the theme is perhaps more tormented than ever. Despite the economic reawakening, which basically started with the entry of Portugal into the European Community in 1986 and the emergence of a wealthy consumer society, entire sections of Lisbon's population seem to have fallen victim to stress and an acute form

Above: The Monument to the Discoveries (Padrão dos Descobrimentos), 52 metres (171ft) high, was erected in 1960 at the height of the Salazar regime. It commemorates the 500th anniversary of the death of Henry the Navigator, the famous prince who, in the fifteenth century, instigated the voyages of discovery to the coasts of Africa.
Opposite: Detail of the Monument to the Discoveries in the Belém district, showing Henry the Navigator, who holds in his hands the first caravel, which he is about to launch.

Above: In the Rua Augusta, the main commercial thoroughfare of the Baixa, a typical small shop offers a wide range of alcoholic drinks. The displays in every shop window are always set out with meticulous care.

of malaise. The fact is that the pace of life in Lisbon has never ceased to accelerate over the last thirteen years. The multiplication of construction and development projects, the explosion in the service industries, the invasion of the city by the motor car, and the impact of consumer credit have all helped to disorientate many older people, whose long lives were lived out during the Salazar dictatorship. As the rural exodus continues and more and more former colonials return to the country, Lisbon has continued to expand and thrust outwards. Little by little it has become a huge agglomeration, whilst its less affluent quarters have turned into a kind of ghetto for those overtaken by the speed of change.

More generally speaking, Lisbon has for some time been in the throes of a combination of social, economic, and cultural changes. Full of vitality and ever in search of novelty, the younger generation – the children of the Carnation Revolution of 1974 – are right at the centre of this process, despite their indissoluble attachment

to the old spirit of their capital. In a city which ceaselessly evokes memories of the past, tempers the body but can break the heart, there is a stampede of young Lisboans almost every night to bars dispensing wistful and brooding music, which remain the focus of attention until at a precise hour the livelier atmosphere of dance halls and discos exerts a more powerful counter-attraction.

The night of Saturday, October 25 1997, on the 850th anniversary of a city with links to such great names as Ulysses, Afonso Henriques, Columbus, Vasco da Gama, Camões, Pombal, and Pessoa, saw tens of thousands of young people out and about enjoying their favourite evening pastimes, debating over glasses of wine and taking in the music scene. They were everywhere, unanimously celebrating their role in this city, at once its children and its hope for the future. The fact is that to visit Lisbon, a city which knows no half measures, is to take a sudden plunge into reality.

Above: This terrace on the Avenida da Liberdade reminds us how much the people of Lisbon love their cafés. They go there alone, in pairs, or in groups, most commonly to drink coffee, a highly popular beverage.

THE HEART OF PORTUGAL

Around the capital is a region which includes the finest sights and monuments. Óbidos, Sintra, Tomar, Cascais… a host of famous names and spectacular places to visit amid the country's most beautiful landscapes.

Opposite: A charming little house decorated with white and blue azulejos, designed to catch the sun, and roofed in typically pleasant style with pretty orange tiles.

SINTRA

Sintra is a small, quiet town, full of history and romance. For centuries one of the most important Moorish strongholds, it then became the residence of the Portuguese monarchy, while today UNESCO has classified it as a World Heritage Site. Nature is utterly in harmony with the stones of Sintra, the scenery appearing to act as a setting for the jewel-like variety of its palaces and magnificent villas. Characteristic of Sintra's landscapes is the serra, or mountain chain, covered in abundant vegetation. Nature here is prolific, full of exuberance and variety. She surrounds the town, nestles up to it, is so closely wedded to it as almost to overwhelm it. Everywhere huge flowerbeds, different species of trees, bushes, and ornamental grasses, bring cheer and colour to the centre of the town, which is dominated by a forest clinging to the flanks of the serra.

In the heart of the old town, picturesque and brightly painted houses are ranged about the royal palace, often decorated with white and blue azulejos, and roofed in typically pleasant fashion with pretty orange tiles. The Palácio Nacional, which was the royal summer residence of the kings of Portugal up to the end of the sixteenth century, reflects the influence of the Moors as well as the

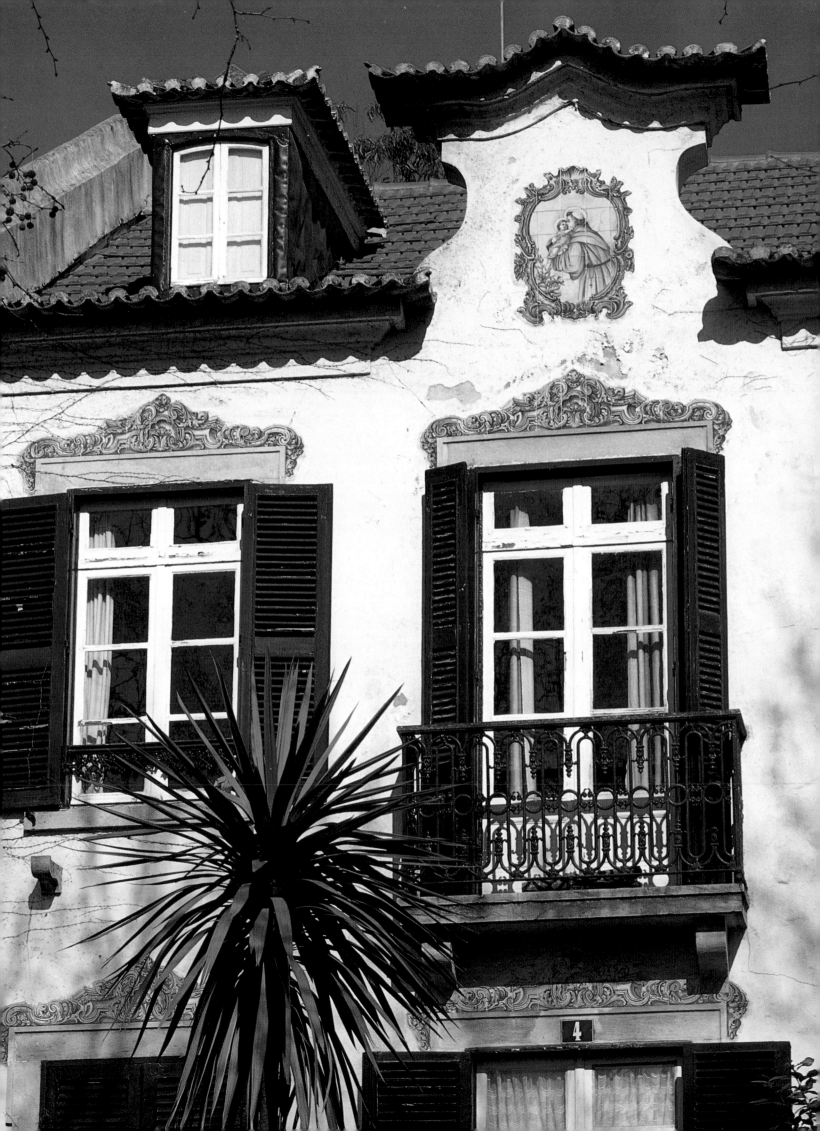

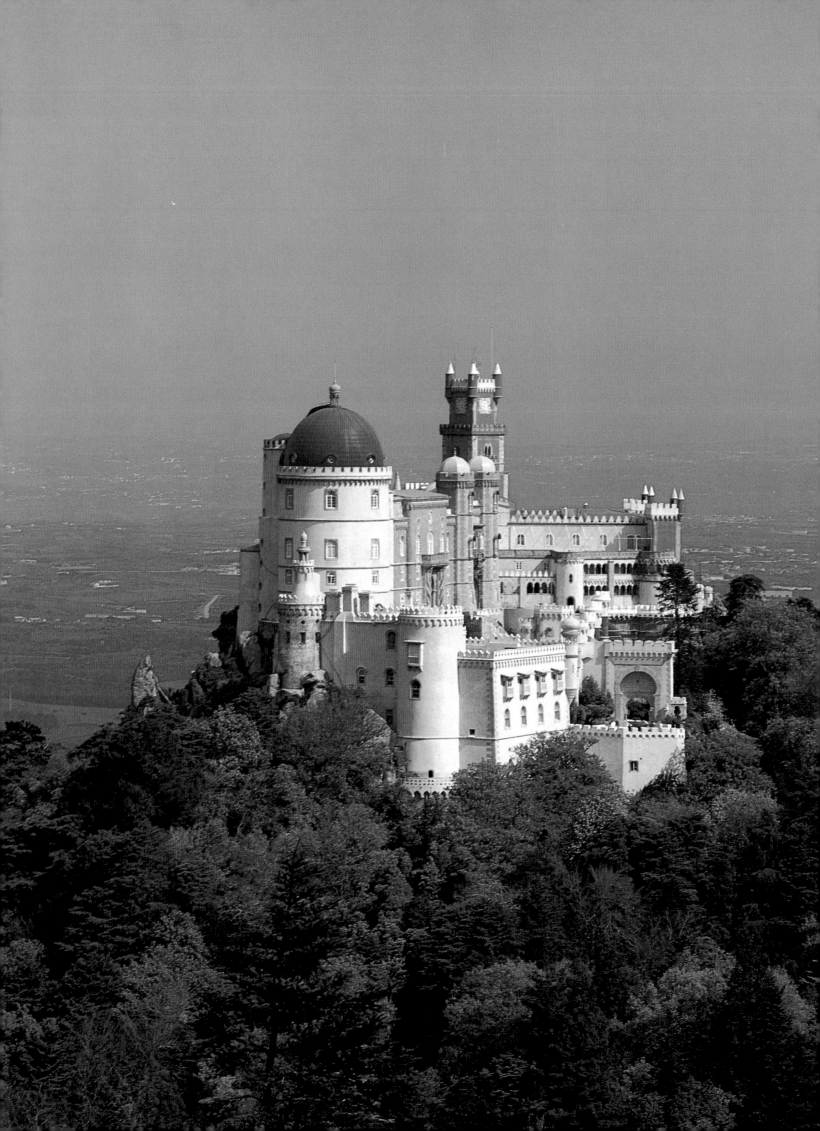

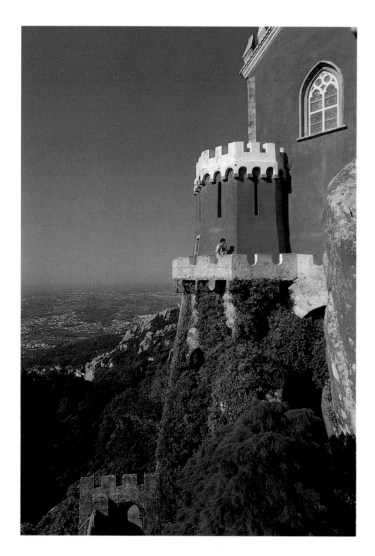

Left: Constructed on the base of the former monastery of Our Lady, which he had purchased, the fairy-tale Palácio da Pena was built by Prince Ferdinand of Saxe-Coburg-Gotha in the mid-nineteenth century.
Opposite:
The Palácio Nacional da Pena, 4 kilometres (2.5 miles) from the historic centre of Sintra and 500 metres (1,640ft) up on a small mountain range, is one of Portugal's most stunning monuments.

Gothic and Manueline styles. Its construction lasted more than two centuries, mainly under the Avis dynasty, and particularly Manuel I, who endowed it with a sumptuous splendour. He had the palace altered after his own style, adding several groups of buildings, replacing the Gothic windows with elegantly ornate Manueline substitutes and enriching the interior with an ambiance of wealth and pride. Today the palace boasts the world's most important collection of azulejos mudéjar – enamelled ceramic wall tiles of the sort made by Moslem artisans who remained on the Iberian Peninsula after the reconquest.

The traveller who heads for the foothills, taking a road winding its way up the wooded slopes, will arrive at the remains of what is still one of the most impressive constructions of the Moslem era: the

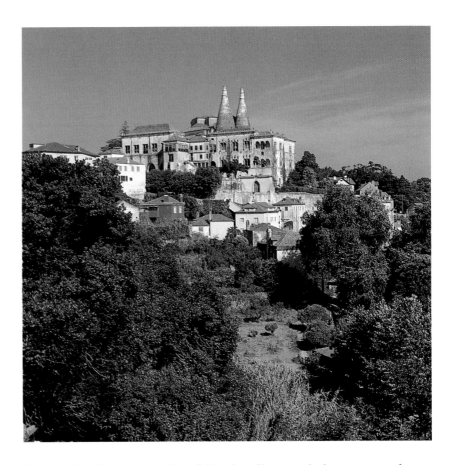

Right: The Palácio Nacional de Sintra is a former royal residence constructed from the thirteenth to the sixteenth century under the Avis dynasty and particularly Manuel I, who endowed it with sumptuous splendour.

Castelo dos Mouros or Moors' Castle. All around, the rampant forest smothers the mountain crag with its centuries-old trees, tangled undergrowth and a damp, green blanket of ferns and mosses. The castle was probably erected at the end of the eighth century, after the Moslem occupation of the Iberian Peninsula. At the end of the eleventh century, due to internal disputes which divided the Moors, Al Mutawakil of the kingdom of Badajoz ceded the castle to Alfonso VI, King of Léon and Castile, in exchange for his protection. Other Moors recaptured it some years later, before Afonso Henriques, the first king of Portugal, took definitive possession. Of strategic importance, the Castelo dos Mouros dominates the entire region from its hilltop position, affording a magnificent view from its solid, grey stone walls over the coastal plain, the shoreline and the Ocean.

A little further along the Pena road the fabulous Palácio da Pena comes into view. Four kilometres (2.5 miles) from the historic

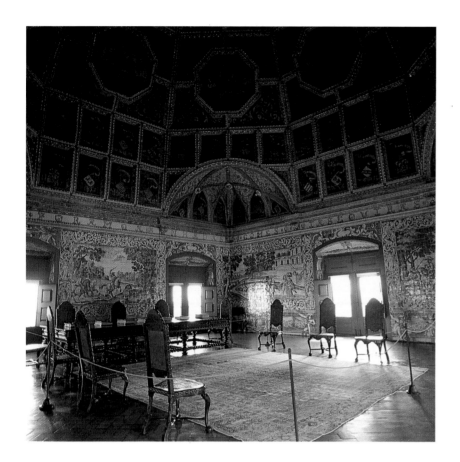

centre of Sintra and 500 metres (1,640ft) up, this fairy-tale palace represents the extreme example of Portuguese Romantic architecture. It was Ferdinand of Saxe-Coburg-Gotha, the husband of Maria II, who in 1839 purchased the ruins of the former monastery of Nossa Senhora da Pena (Our Lady of Pena) dating from 1503, and replaced it with this extraordinary edifice. Its keep is Gothic, its minarets Arabic, the windows and cloister Manueline, and it has a Renaissance altarpiece – all in all a flamboyant example of eclecticism.

Sintra, the 'glorious Eden' eulogized by Lord Byron in *Childe Harold's Pilgrimage* (1812), still attracts as many tourists – and trippers from Lisbon – as ever, such is the spell cast by its many splendours and its unsurpassed romanticism.

Left and above: The Palácio Nacional de Sintra today contains the world's finest collection of 'azulejos mudéjar': ceramic tiles based on the style employed by Moslems who remained in the Iberian peninsula after the reconquest.

Above and opposite: The Cabo da Roca (Cape Rock), on the Atlantic coast not far from Cascais, is at the extremity of the Serra de Sintra, and is the westernmost point of continental Europe.
Previous pages: 20 kilometres (12.5 miles) from Lisbon, where the waters of the Tagus flow into the Atlantic, the Bay of Cascais has become a favourite resort for those wishing to escape the capital.

CASCAIS

The town of Cascais, 20 kilometres (12.5 miles) from Lisbon and situated just at the mouth of the Tagus, where river and ocean meet, is a favourite resort for those wishing to escape the capital. Not far from Estoril, where there is a concentration of villas belonging to Portugal's great families, Cascais is an old fishing village established by the royal family as its summer quarters in the last century. The climate here is particularly mild, and the coastline has much to offer. Cascais and its neighbours enjoy a varying shoreline. There are bays, beaches, and the steep cliffs where fishermen cast their lines, alternately caressed or battered by the waves of the Atlantic, and bathed by warm, strong sunshine. Built on the westernmost headland of the Tagus estuary, a fortress, dating from the seventeenth century and facing the sea which it guards, reminds us that Cascais was once a strategic town commanding access to the river. Below, the harbour of Cascais, still in use as the home base for its

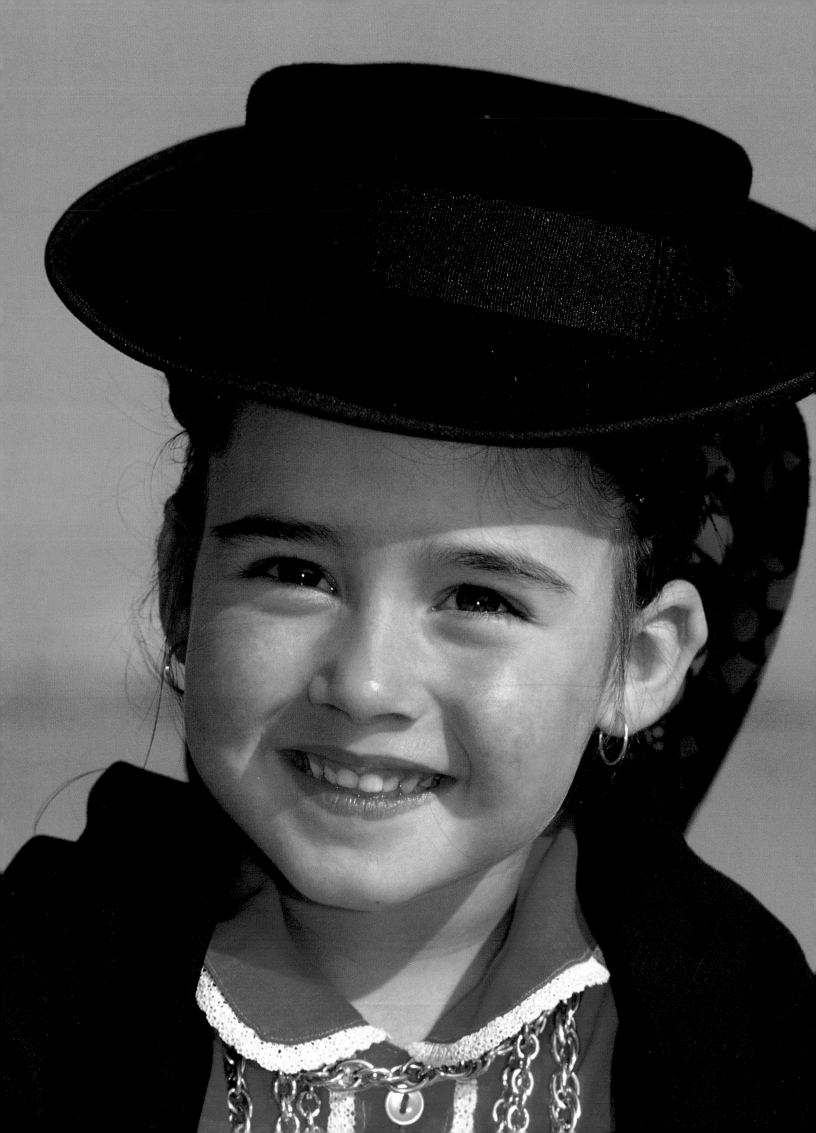

brightly painted boats operating just off the coast, perpetuates the old fishing tradition. Whether fishing from boats or the shore, the important thing for fishermen here is to be close to the great blue ocean. The shore-fishermen give the impression of conducting some priestly ritual, so unhurried are their actions, every movement reduced to the absolutely essential. Rod-and-line fishermen indulge their passion chiefly from the rugged and dangerous cliffs near the Boca do Inferno, or Mouth of Hell. The mouth is in fact a cliff hollowed out by the waves which sweep into the cavities with a powerful and fearsome roar, driving up packets of foam into a sort of gorge.

Moving on from Cascais, the Cabo da Roca is situated 144 metres (472ft) above sea-level and is an extension of the Serra de Sintra, marking its very extremity. It is also the westernmost point of continental Europe.

Top: The shore around Cascais consists of a variety of bays, beaches, and steep cliffs, from which fishermen cast their lines.
Above:
The basin at Cascais, with its little harbour, maintains a fishing tradition.
Opposite:
A young lady of Cascais, who, judging from her expression, is obviously thriving on the sea air.

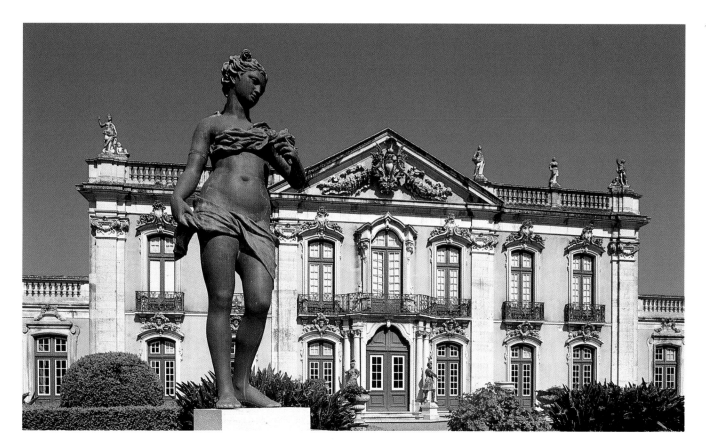

This page and opposite:
The Palácio Nacional is a former
royal residence built in the
eighteenth century by the Infante
Pedro, the future Pedro III, and
continued by João VI till 1807, when
the family left for Brazil. With its
varnished floors, crystal chandeliers,
paintings, and gilding, the Palácio
brings together the most exquisite
artistic achievements of the period.

QUELUZ

The small town of Queluz, situated some 15 kilometres (10 miles) from Lisbon is distinguished chiefly by its Versailles-inspired royal palace. The Palácio Nacional was constructed in the eighteenth century by the Infante Pedro, the future Pedro III, and continued by João VI up to 1807, when the royal family left for Brazil. Designed, like Versailles, to be the symbol of a prestigious monarchy, this palace, where the most exquisite artistic achievements of the period have been assembled, possesses an interior which matches its outward appearance in splendour. There is a magnificent Garden of Neptune, for example, laid out in front of the palace and designed in the Le Nôtre style around a large pool, whose statues are veritable masterpieces. In the park below, the walls, fountains, and flights of steps, all clad with polychrome azulejos, add an extra touch to the already magnificent gardens.

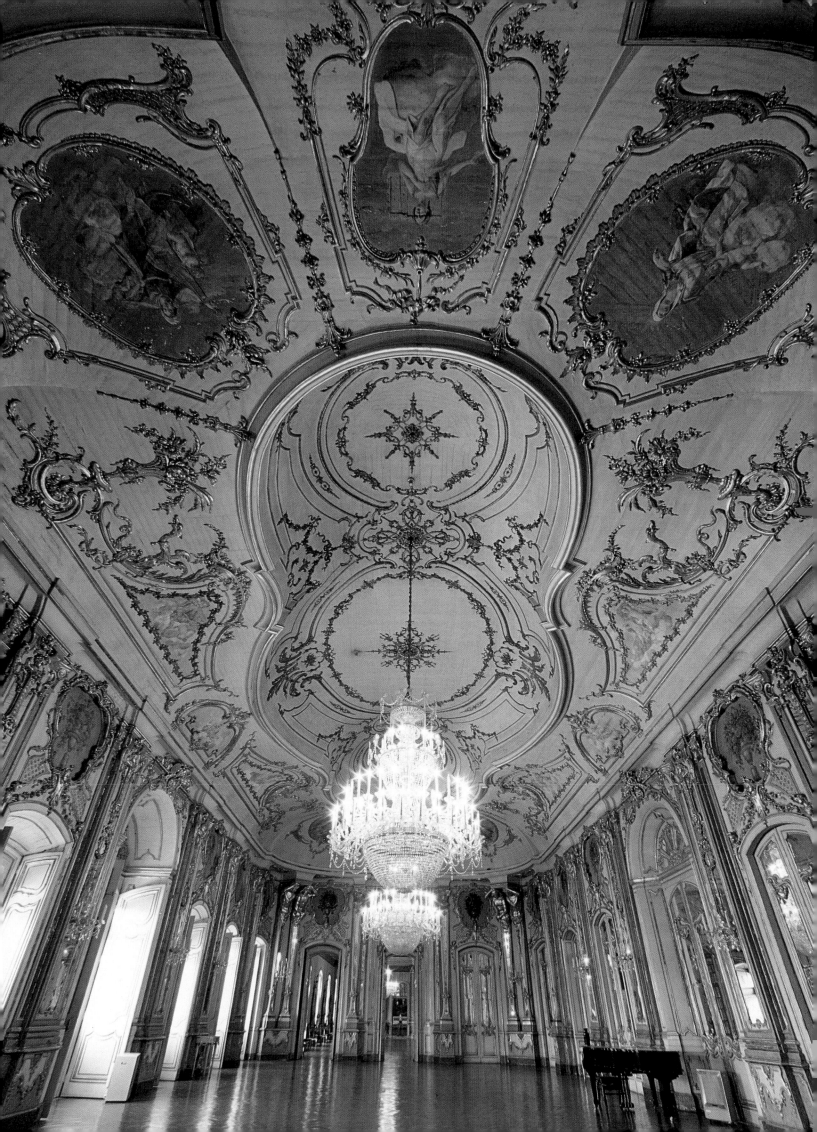

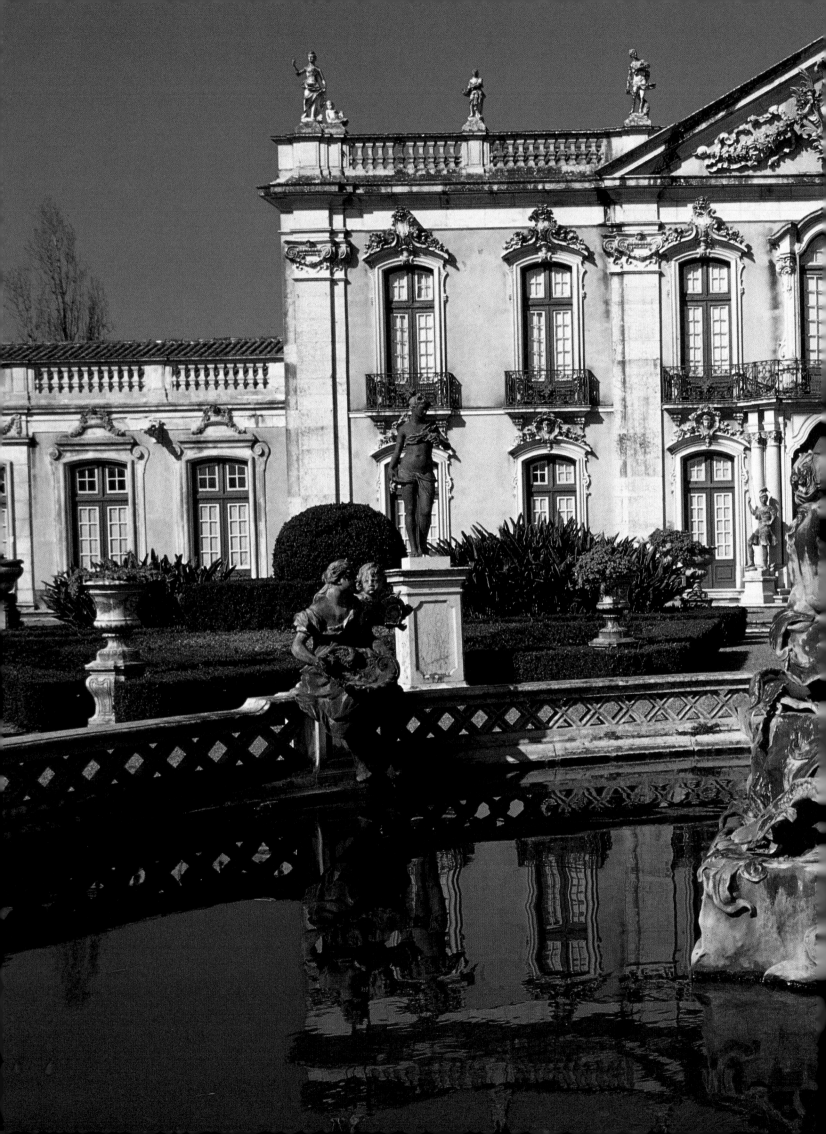

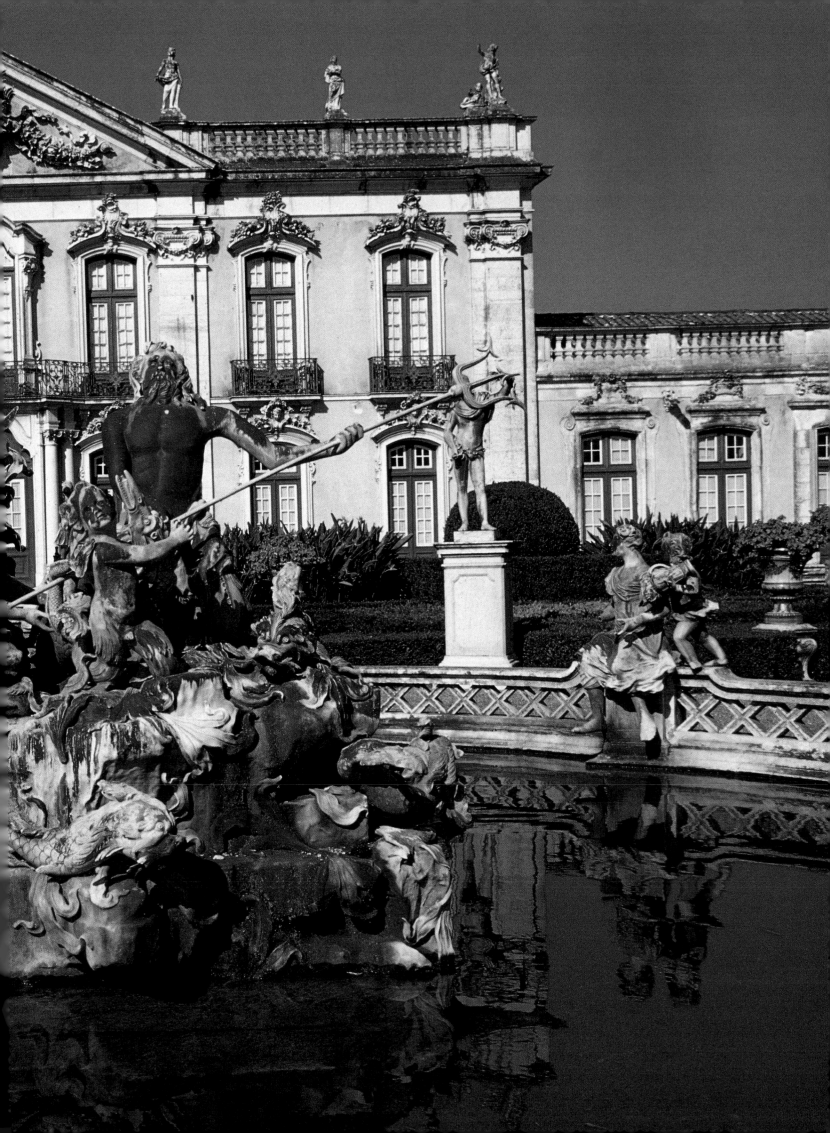

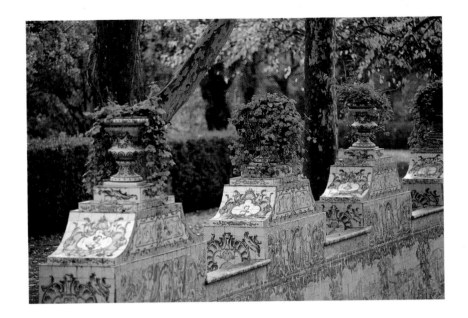

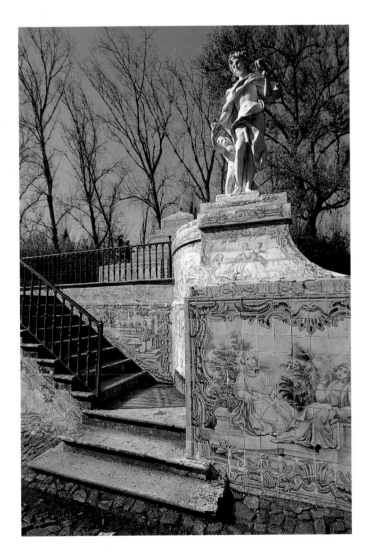

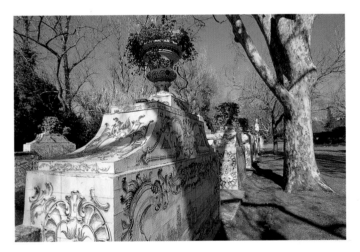

T his page and opposite: In the park below the palace, walls, pools, and staircases covered with polychrome azulejos add an extra touch to the magnificent gardens.
Previous pages:
In front of the palace, the Neptune Garden, arranged in the Le Nôtre style around a large pool, is a minor masterpiece.

Above:
Constructed in fulfilment of a vow by João V, the monastery at Mafra, which also doubled as a palace (Palácio de Mafra), is one of the finest baroque buildings in Portugal.
Opposite:
The facade of the Palácio de Mafra, built between 1717 and 1730. Superimposed rows of columns are surmounted by a somewhat sober pediment, on either side of which rise impressive towers.

MAFRA

An old town captured from the Moors in 1147, Mafra consists of an ancient settlement and a new community which has grown up round the famous monastery. Built in fulfilment of a vow by João V, this monastery, which doubled as a palace, is in fact one of the finest baroque buildings in Portugal. Its facade, dating from between 1717 and 1730, takes the form of two superimposed rows of columns surmounted by a somewhat sober pediment which in turn is framed by two ornate bell towers. Inside, the monastery's royal basilica, particularly remarkable for the quality of its pink and grey marbles, conjures up the spirit of St Peter's in Rome. Immense and magnificent, the monastery-palace contains dozens of rooms, corridors, and galleries with in all at least 4,500 doors and windows. Not to be missed is the library, installed in 1771 in a fine baroque gallery, with a collection of some 40,000 volumes.

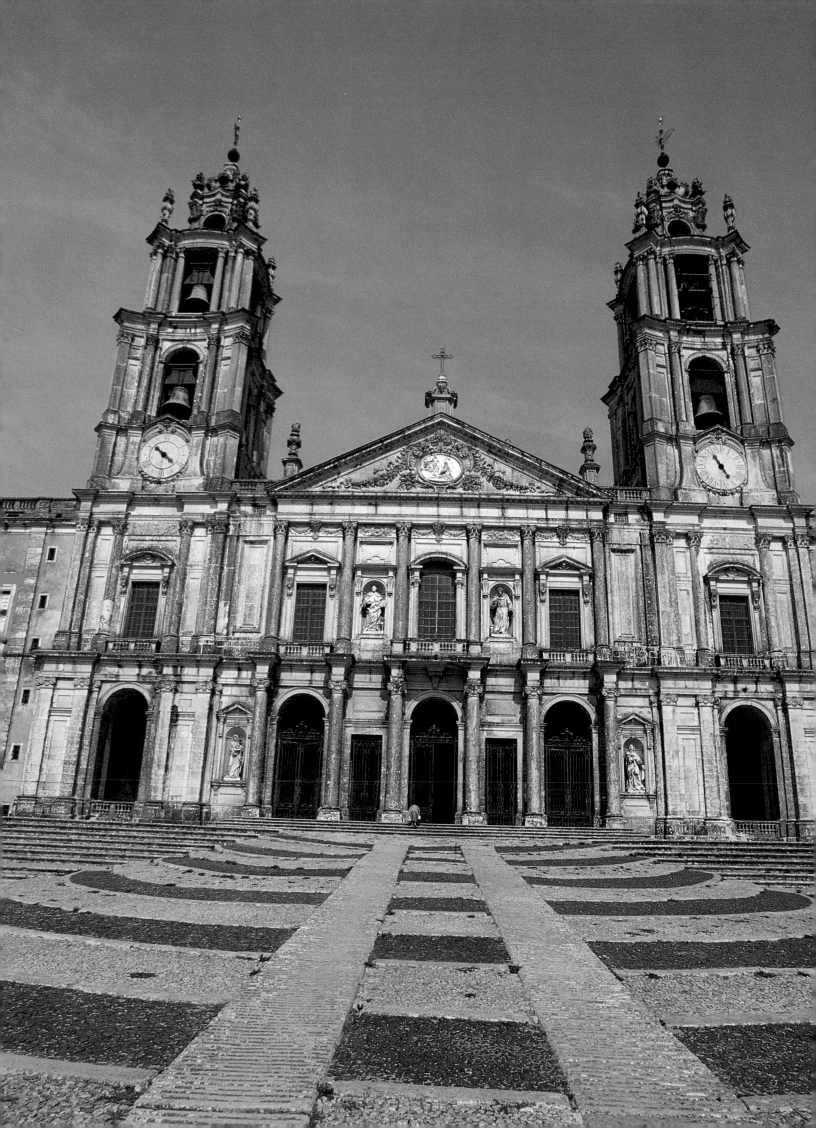

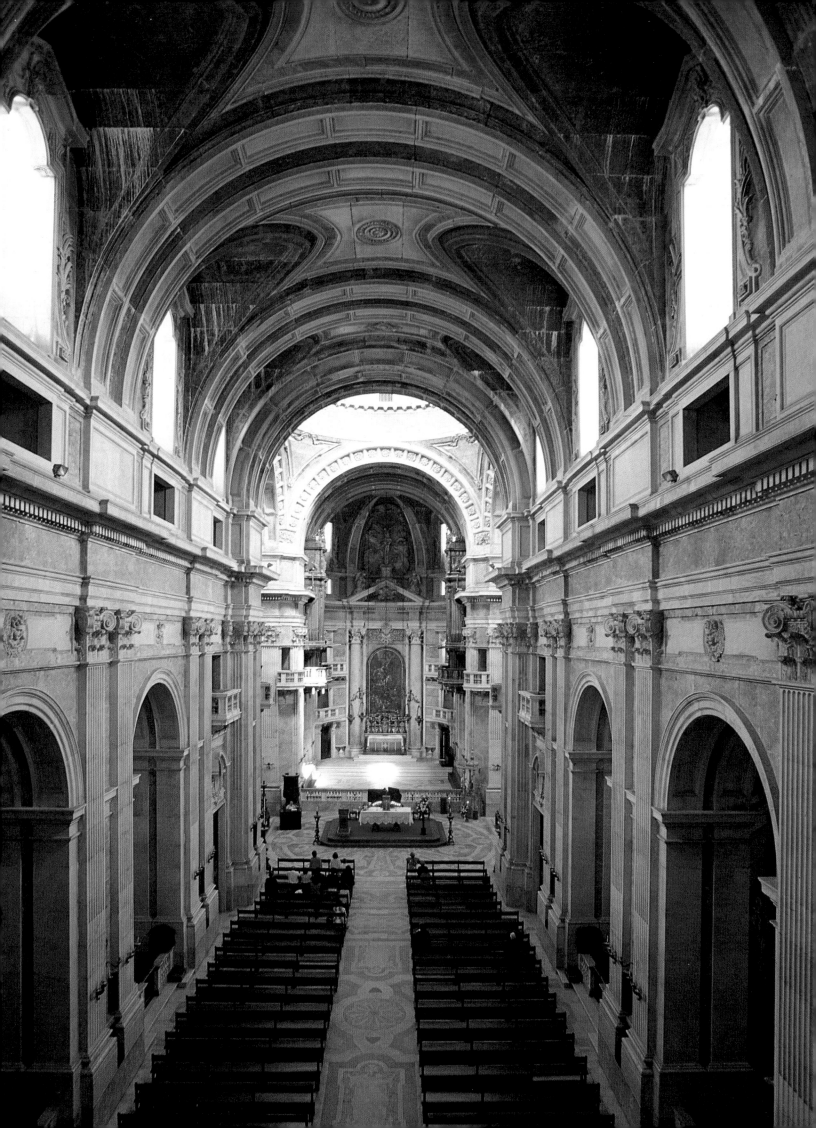

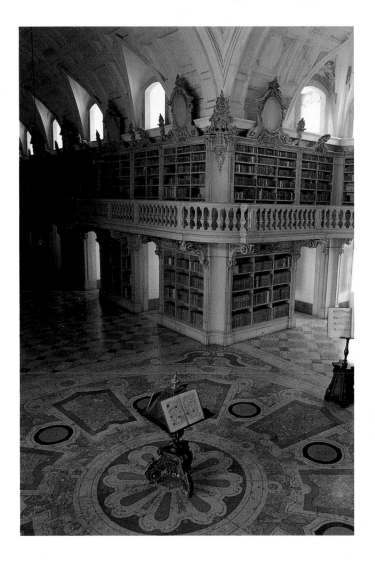

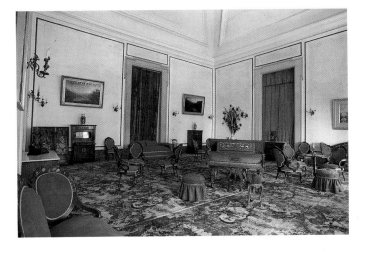

*T*op and above:
Immense and magnificent, the
monastery-palace possesses at least
4,500 doors and windows.
Left:
The library at Mafra, a fine baroque
gallery, contains around 40,000
volumes.
Opposite:
The monastery's royal basilica is
particularly remarkable for the
quality of its pink and grey marbles.

Above and opposite:
With its low, whitewashed houses
and walls with blue and yellow
trimming, its weathered tiles and
winding, cobbled alleys, the little
town of Óbidos is a charming old
place exuding the spirit of Portugal.

ÓBIDOS

A small town which Dinis I presented to his queen Isabel, Óbidos retains the special appeal – a mellow, rather feminine character – which attracted the king's young wife at the beginning of the four-teenth century. In fact, all the subsequent queens fell in love with its low, whitewashed buildings, cobbled streets winding between houses bright with flowers, and walls snaking along the contours of the hills. Óbidos became their personal retreat because of its peace and tranquillity. There are seven churches (including Santa Maria, which is covered with azulejos) which together with the white houses and the alleys, are grouped around a powerful castle, now transformed into a *pousada*, or state-administered hotel. Taken from the Moors in 1148, the castle was restored and enlarged by Kings Dinis, Fernando and Manuel. It is shaped like an isosceles triangle, with a high keep forming the apex to the north. The crenellated ramparts offer a pleasant walk and a bird's-eye view of the town.

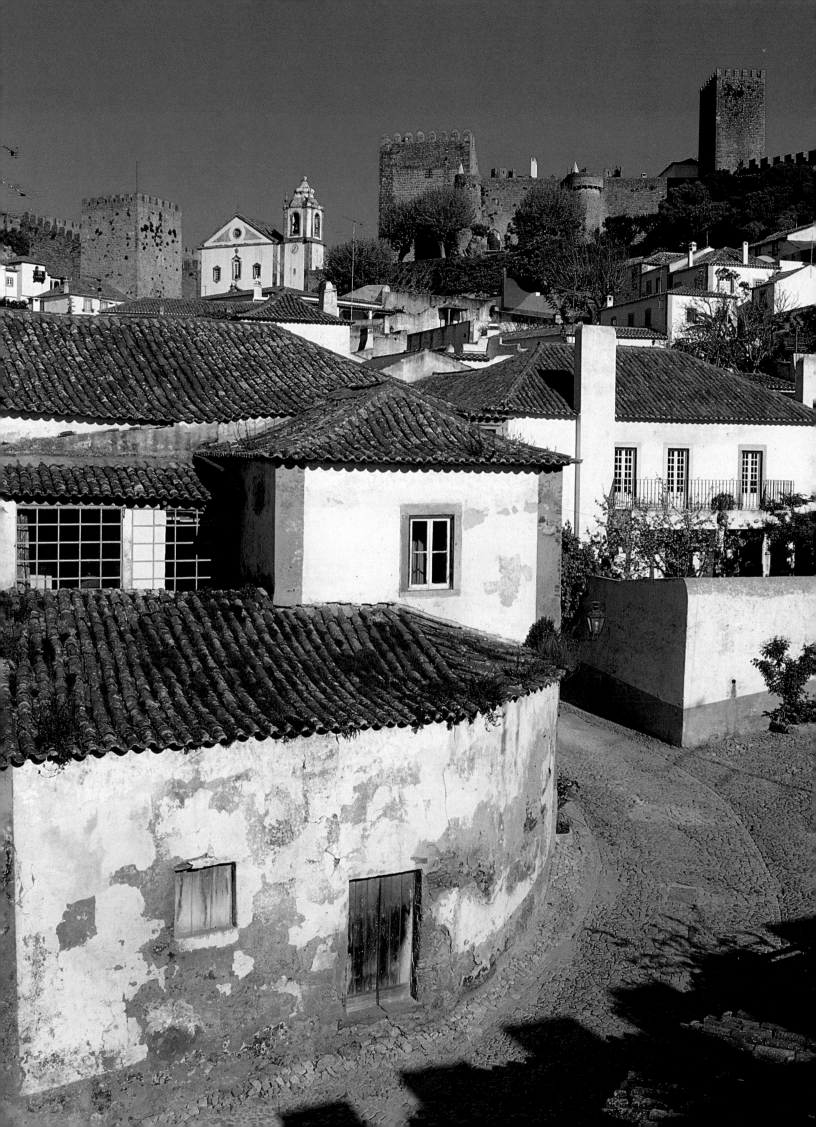

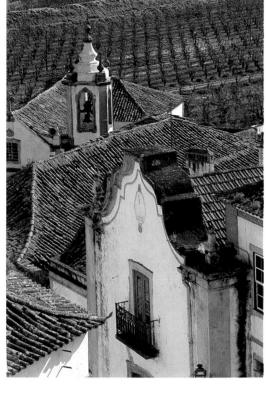

*T*his page: small gardens, well
maintained and often full of
flowers, surround some of the
old-style houses.

Opposite:

The church of São Tiago and the
castle ramparts dominate the huddle
of nearby houses.

Overleaf:

Despite successive alterations, the
castle at Óbidos, in a remarkable
state of preservation, immediately
takes the visitor back to the days of
medieval Portugal.

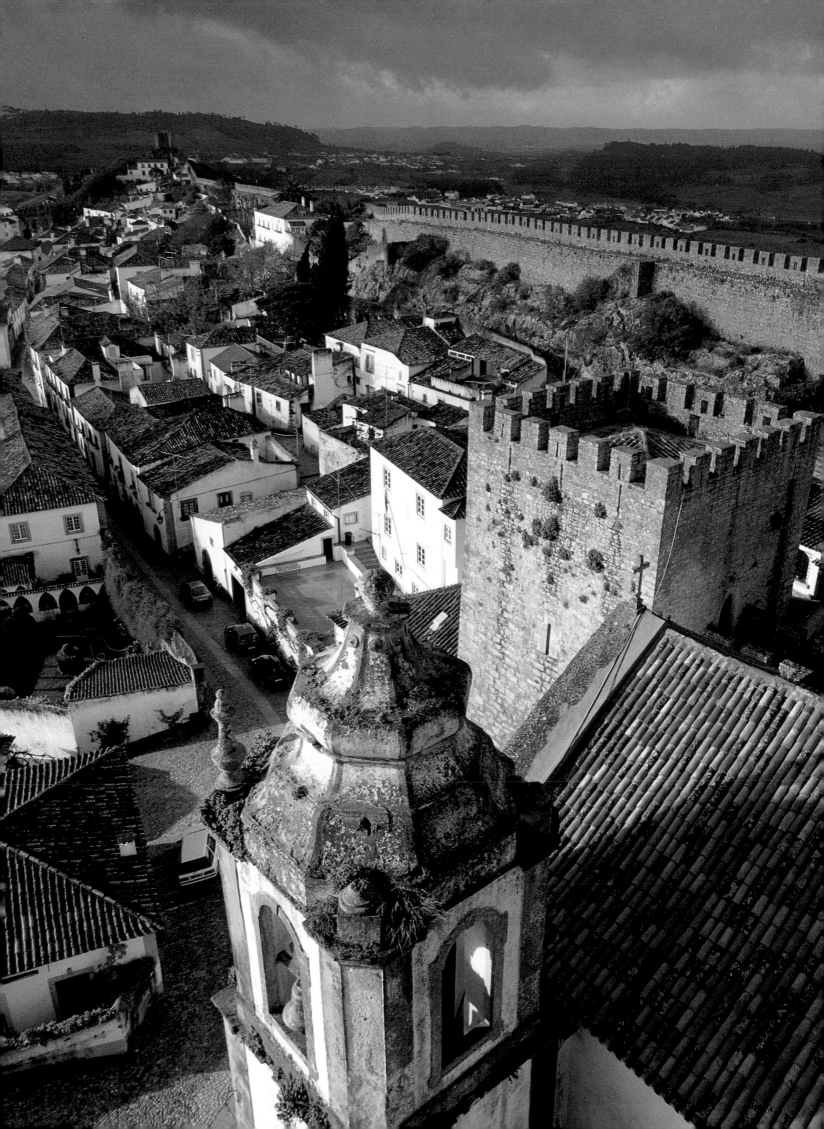

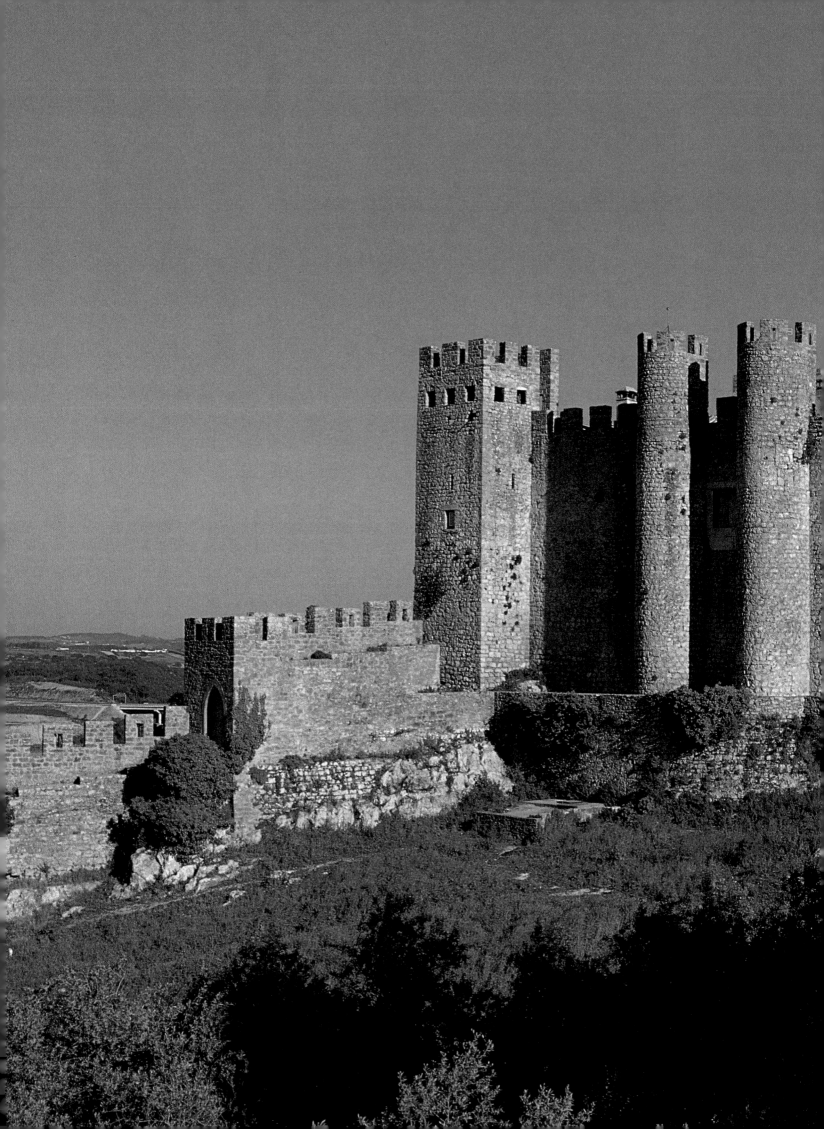

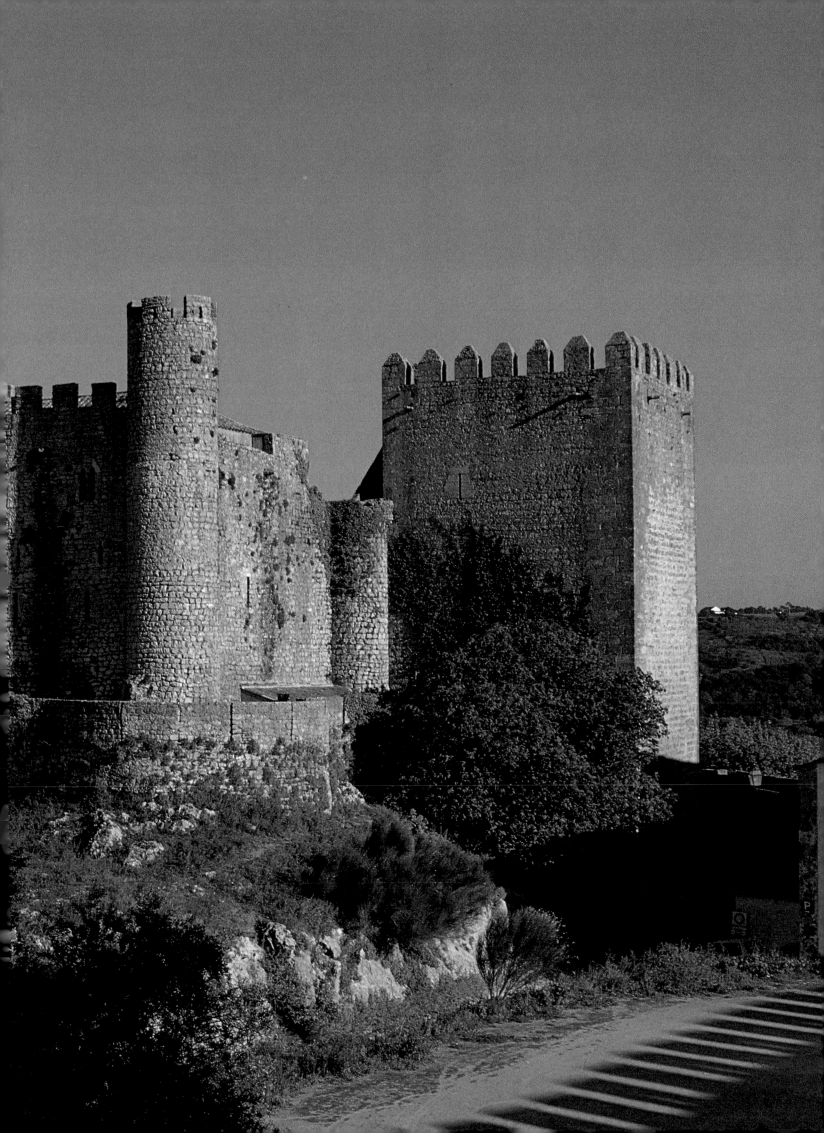

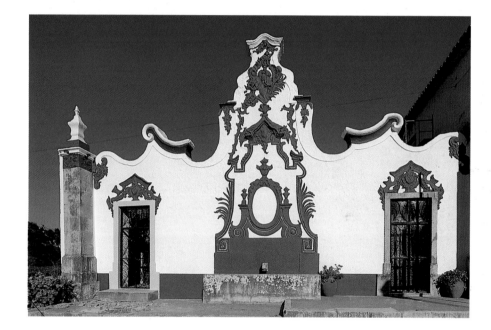

*T*his page and opposite: These two colours, ultramarine and burnt yellow, standing out against the whiteness of a wall or the vermilion of a door, are part of a tradition found elsewhere in Portugal, for example in the Alentejo.

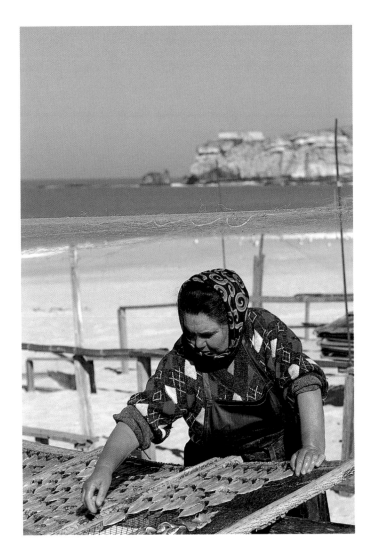

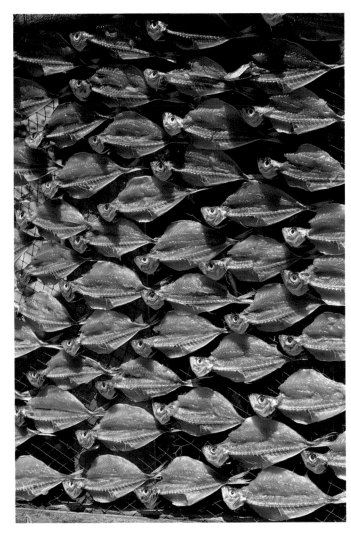

*T*his page:
The fishing town of Nazaré was once famous for its womenfolk who worked on the beach, drying the cod catch straight from the boats. It is still one of the top resorts in Portugal, prized for its sweeping bay, which ends in a spectacularly sheer cliff 110 metres (361ft) high.
Opposite and overleaf:
The Costa da Prata (Silver Coast) is typical of the Beira Litoral, but the seafront and huge bay at Nazaré are its most striking features.

NAZARÉ

Nazaré is an old fishing town which has become one of the most sought-out resorts due to its excellent coast and bay. The town consists of three districts, which are villages in their own right: Pederneira, the old quarter, abandoned by the fishermen in the sixteenth century for a site nearer the sea; Praia, the heart of the resort with its extensive seafront; and Sítio, perched on a cliff dominating the bay. If Nazaré has gained a worldwide reputation, it is because it has preserved its own customs and regional folklore. Among the fishing community, women traditionally wore pom-pom skirts revealing seven layers of different-coloured petticoats, each embroidered with lace trimmings, whilst the men sported woollen shirts with large check patterns.

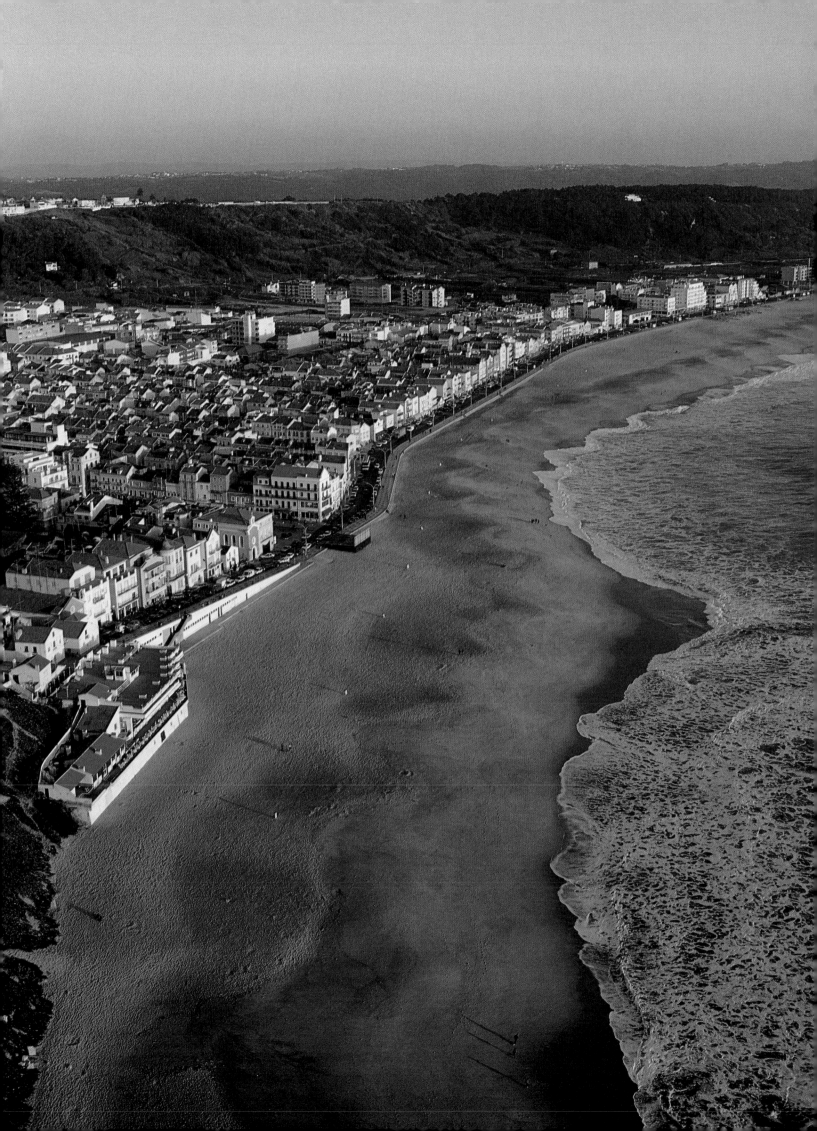

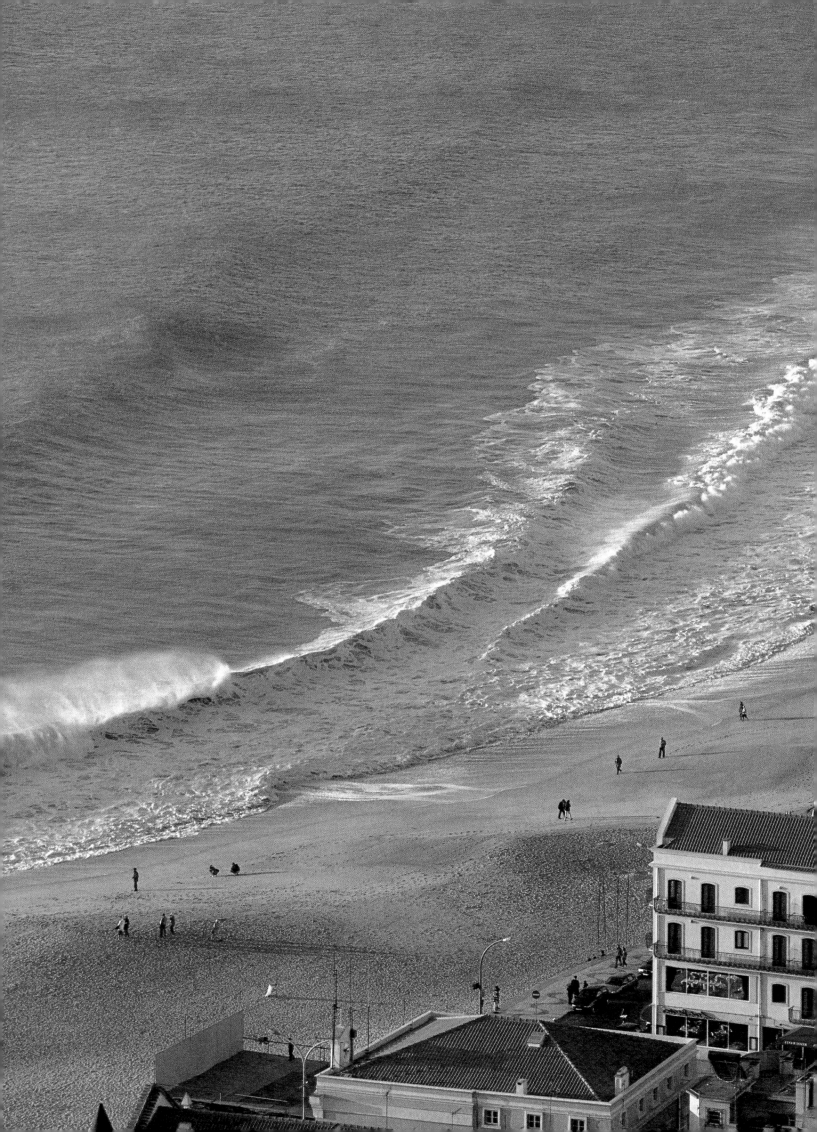

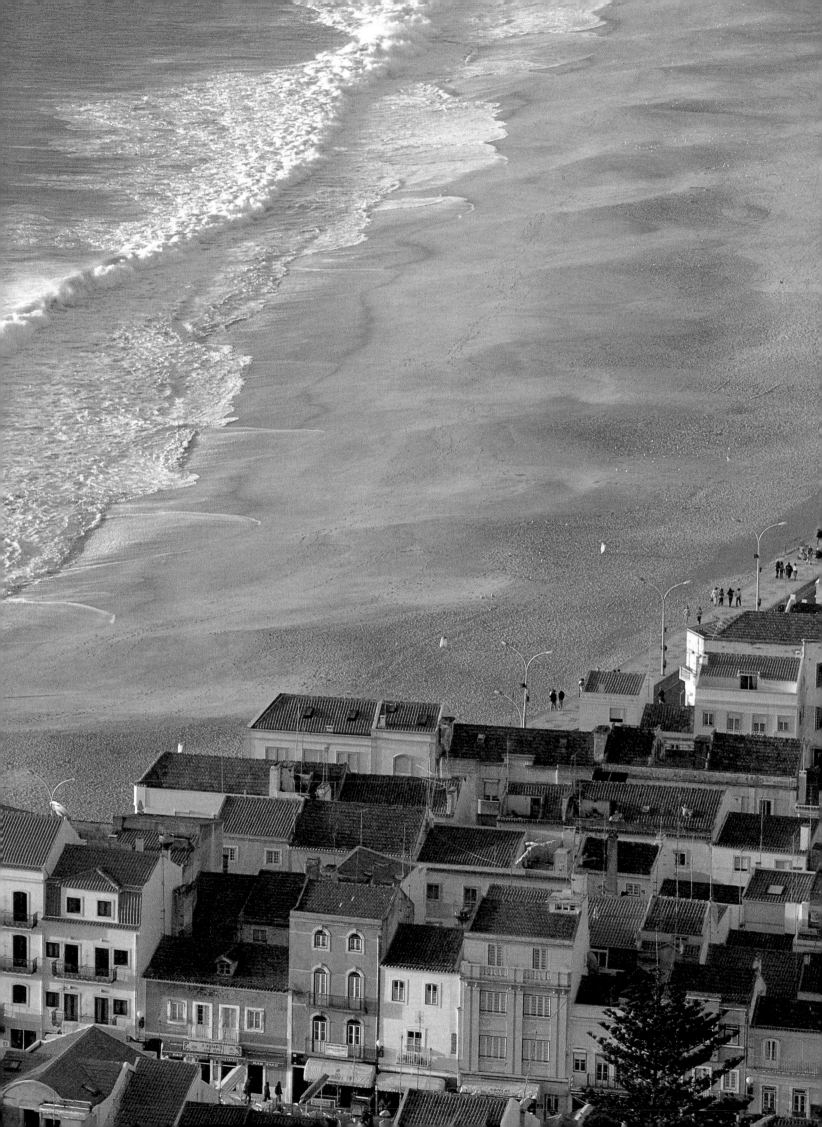

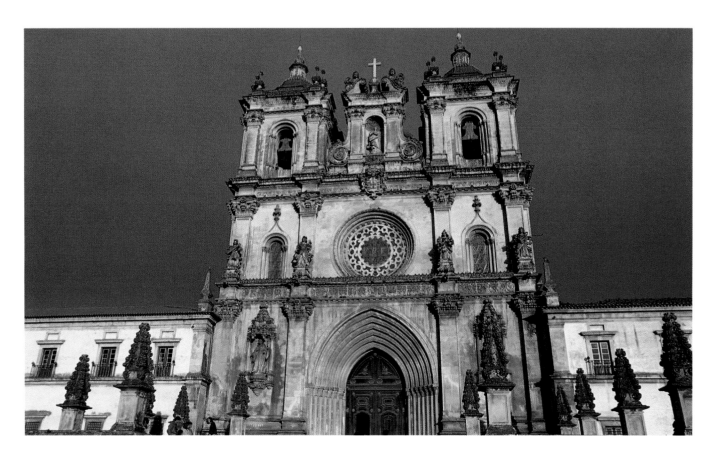

*T*he Mosteiro de Santa Maria at Alcobaça has a baroque facade but inside remains a monument to Gothic inspiration and Cistercian monasticism. The mixture of styles redounds to the glory of this prestigious abbey.

ALCOBAÇA

Now the centre of a fertile agricultural and horticultural region with its thriving orchards and vineyards, the present site of Alcobaça was a wild, uncultivated, marshy piece of land with little promise before King Afonso Henriques ceded it in 1153 to the Cistercian monks in fulfilment of a vow after the capture of Santarém (1147). Monks from Clairvaux, the abbey founded in the French *département* of Aube by the Abbot of Cîteaux in 1115 – their first abbot was St Bernard – came to exploit the land and construct a monastery worthy of their austere form of Christianity. The first abbey was begun in 1178, at a time when monasticism was beginning to play an important part in the life of the country at large. Destroyed by the Moorish forces at the end of the twelfth century, it was rebuilt during the thirteenth, to be further embellished during the reign of successive Portuguese monarchs. Thus the powerful baroque facade towering over the large parvis and broad steps is the result of alterations dating to the beginning of the 1600s.

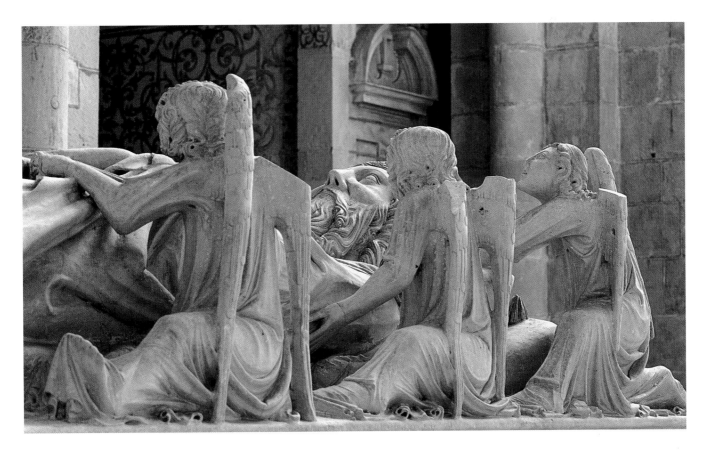

The 1755 earthquake necessitated considerable repairs. But on the whole, Santa Maria preserves a purity which is completely Cistercian. Its white, triple nave with its twelve bays is so severe and plain that the sound of footsteps on the floor resound and echo right up to the quadripartite vaulting. Essential to the functioning of the monastery, the kitchens give an indication of the bustling life which once animated them. They are huge in size (18 metres or nearly 60ft high), and the fireplace is so vast that five oxen could be roasted side by side. The centre of intense spiritual activity and a rigorous communal life whose asceticism has been relaxed with time, Santa Maria, classified as a World Heritage Site by UNESCO, is also the final resting-place of a legendary couple, Pedro I and Inês de Castro – the Portuguese equivalent of Romeo and Juliet. In the two opposing arms of the transept, the tombs of these two separated lovers recall, in the sculptured limestone of their memorials, the darker hours of the Portuguese monarchy.

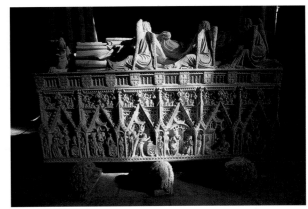

Above and top: In the two opposing arms of the transepts of the Alcobaça monastery are the tombs of Pedro I, King from 1357 to 1367, and of Inês de Castro, a lady-in-waiting at the Court. Pedro's father had Inês murdered to end their relationship, but now the pair lie facing each other for all eternity.

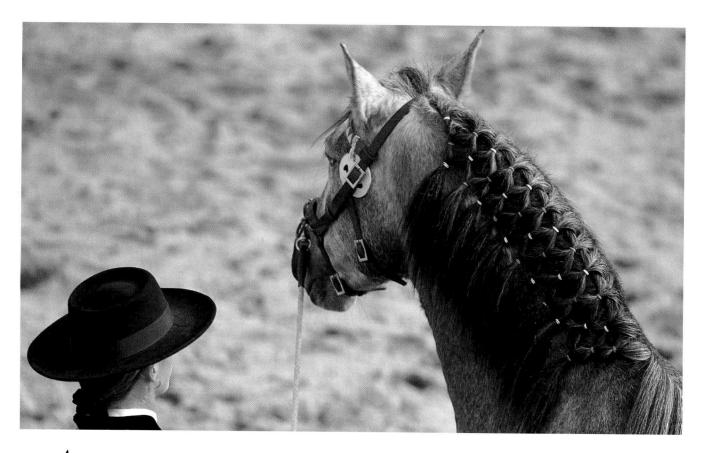

Above and opposite: Golegã, a small town 100 kilometres (62.5 miles) north of Lisbon, has no architectural features of merit and might well have remained totally anonymous were it not for the extraordinary transformation it undergoes for a few days every November. The period around the Feast of St Martin is the occasion of the Feira Nacional do Cavalo or Annual National Horse Show.

• The National Horse Show •

The *Feira Nacional do Cavalo* is in every way a celebration of things equestrian. A large display-ring is set up right in the town centre for five days, and thousands of riders invade Golegã, watched admiringly by tens of thousands of passionately interested spectators. Breeders from all around the country throng to buy and sell horses, some of which command considerable sums. Experienced riders, wearing dark habits and wide-brimmed hats, parade on the finest mounts, whilst the less expert make use of the occasion to practise their skills. The *Feira* at Golegã is both an exhibition of highly precise dressage and a thrilling popular festival, where the horse is king.

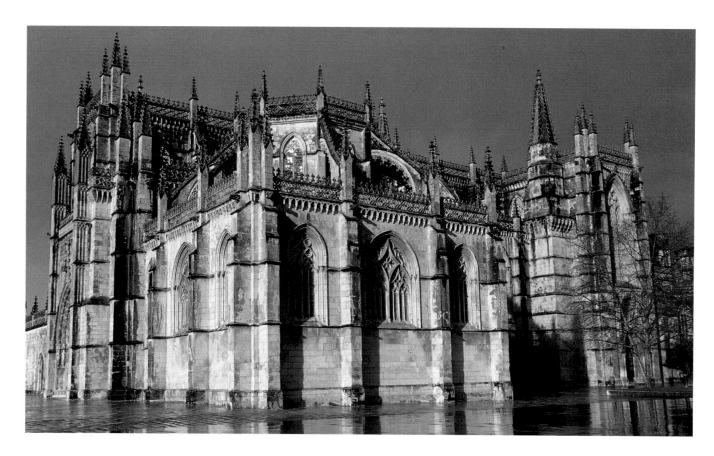

Above: Classified as a World Heritage Site by UNESCO, the monastery of Santa Maria da Vitória at Batalha, an architectural masterpiece, is the fulfilment of a promise made by João I just before the Battle of Aljubarrota in 1385.

BATALHA

A true jewel in Portugal's architectural heritage, the monastery of Santa Maria da Vitória also bears a name which seems incongruous for a building consecrated to the glory of God: Batalha, which means 'Battle'. The fact is that this monument is the fulfilment of a promise made by João I just before the great battle of Aljubarrota on 15 August 1385. This was an engagement decisive for the independence of the Portuguese kingdom, pitting João I – Grand Master of the Order of Avis and son of Pedro I – against Juan I of Castile. Dom João's forces were under the command of Nuno Álvares Pereira, and included English crossbowmen; Juan and his Castilians, aided by a French contingent, were leagued with Queen Leonor, the hated ex-regent of Portugal. Though superior in numbers, the Castilians were routed, and João's prayer to the Virgin was granted. In a final happy sequel to the victory, the monastery began to take shape three years later in 1388.

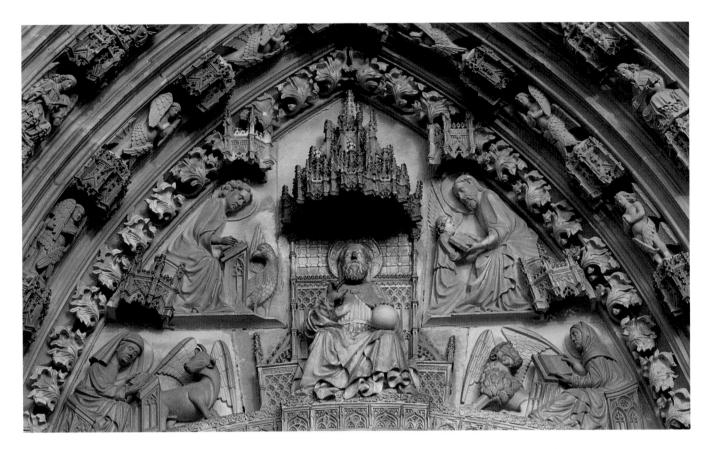

The monastery of Batalha, now classed by UNESCO as a World Heritage Site, is the fruit of a difficult and complex building operation which combined the Manueline and Gothic styles and cost a century and more of toil, during which various architects were employed by a succession of sovereigns. First, Afonso Domingues drew up the plans, taking his inspiration from the Alcobaça monastery for the layout of the nave, the choir, and the cloisters. Then the great Huguet, after finishing Domingues's work and completing the church, set about the installation of the vaulting in the chapter room and Royal Cloisters, and erected the Founder's Chapel to serve as a tomb for the king. He also began to add an octagonal rotunda behind the choir, designed as a mausoleum for the monarchs of the House of Avis. From 1438, after Huguet had spent thirty-six years working on this monument to the Virgin, two master builders from Évora, Fernão de Évora and Martim Vasques, took over in the reign of Afonso V, their main achievement

*This page and overleaf:
The West Doorway of the Batalha monastery erected to the glory of the Blessed Virgin is thronged with dozens of small sculptures. In the centre of the tympanum, Christ is seated with the Four Evangelists.*

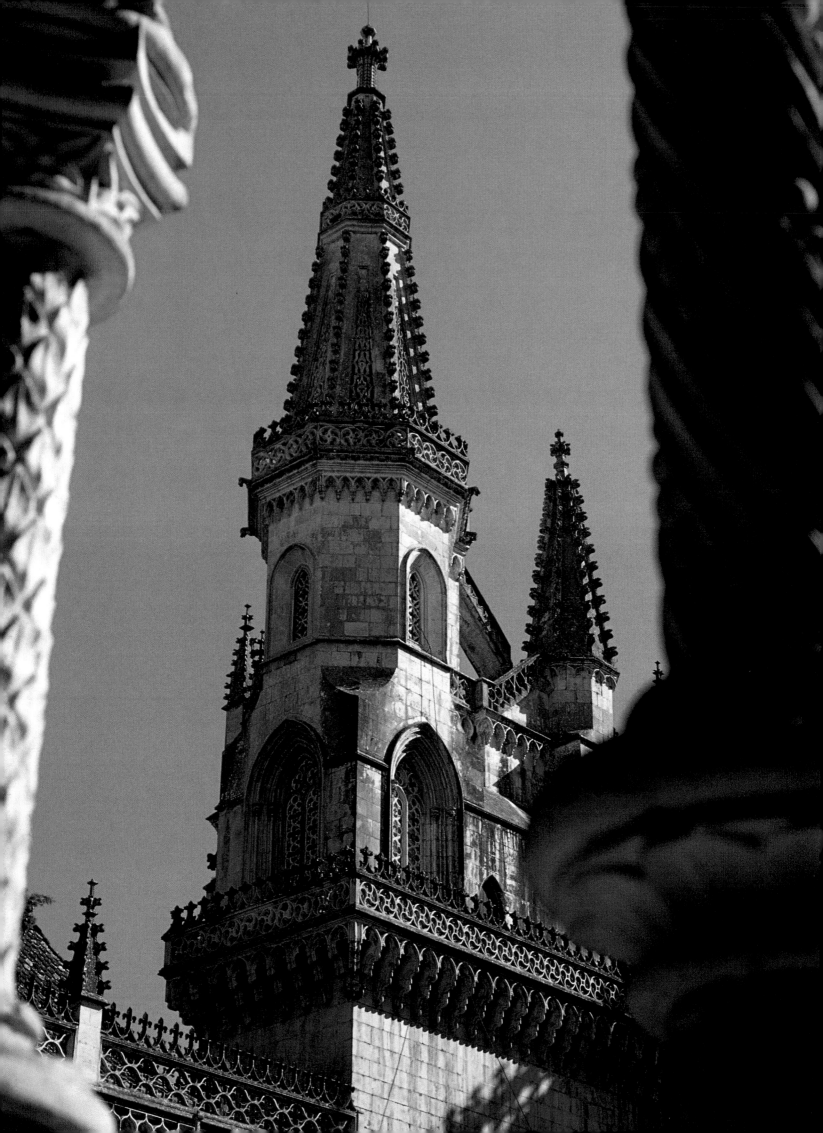

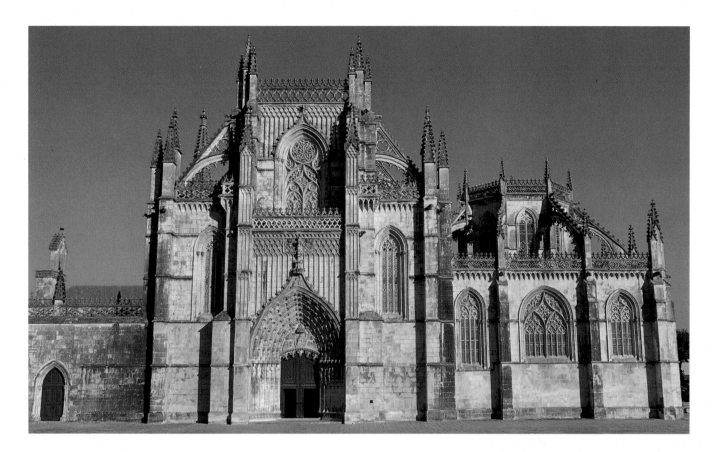

being to add another set of cloisters. Later still, King Manuel ordered

Mateus Fernandes to enter the lists. Fernandes, at the start of the six-

teenth century, oversaw the erection of the great doorway separating

the choir from the 'Unfinished Chapels'. Manuel I also charged Boytac,

the recognized master of the Manueline style and designer of the

Jerónimos monastery at Belém, to complete the efforts of his pre-

decessors. Boytac set his hand to the arcading of the Royal Cloisters,

which he embellished with intricate marble tracery. Nowadays these

cloisters are universally admired, not least because of their effect of

oriental exuberance. This celebrated architect also toiled long at the

'Unfinished Chapels', still roofless today after 400 years.

The building is essentially Gothic. Its interior – pure, sober, even

austere – contains the tombs of numerous kings and princes who

enhanced the glory of Portugal. Here too stands the tomb of the

Unknown Soldier. One of the most famous of the memorials is

that of Henry the Navigator. The third son of King João I, Henry

*This page and opposite:
The roof structures, such as these
turrets with their ribbed pinnacles
soaring heavenwards, lend the
monastery a true Gothic aspect,
which has often been compared to
the English style at York Minster.*

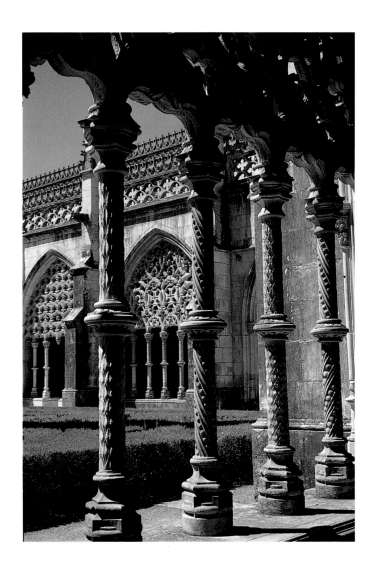

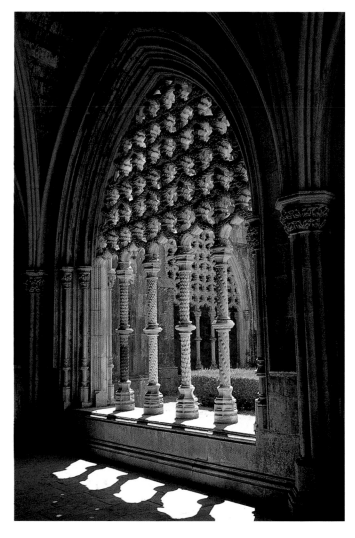

*T*his page:
Under Manuel I, the famous architect
Boytac worked on the arcading of the
Royal Cloisters, embellishing them
with an intricate marble tracery.
Today they meet with universal
admiration, not least because of
their effect of oriental exuberance.
Opposite:
The West Doorway at Batalha.

was Grand Master of the Military Order of Christ, which, from 1418 onwards, was set the task of collecting precious information on unexplored continents, on the principles of navigation, and nautical instruments. This was the man who made the great voyages of discovery possible.

Turning to the exterior, we are drawn to the West Front. The doorway throngs with dozens of small sculptures, in the centre of which, in the tympanum, Christ is seated with the Four Evangelists. Above the entrance rises a fine window in the Flamboyant style.

The roof structures, such as the towers with their ribbed pinnacles soaring heavenwards, lend the monastery a true Gothic appearance, which has often been compared to the English style at York Minster.

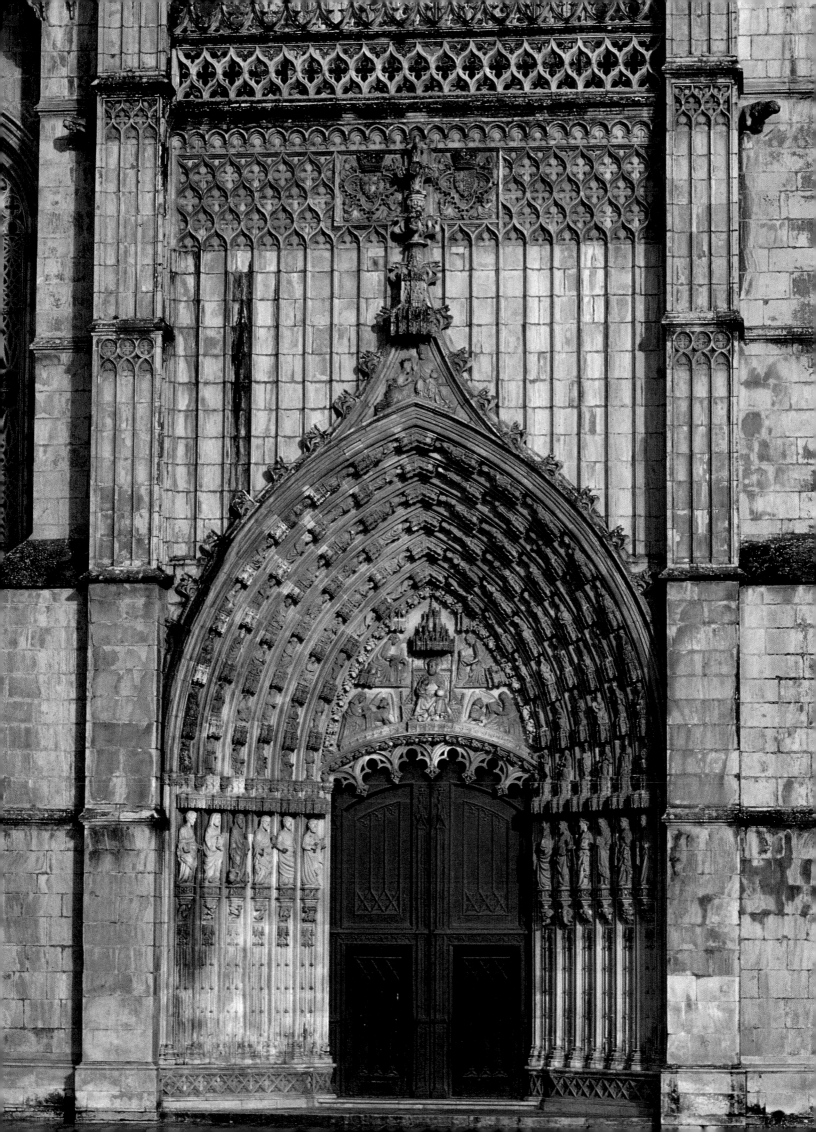

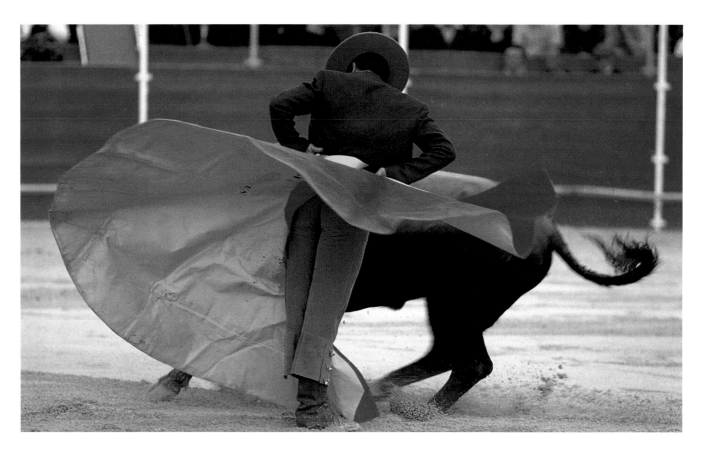

*T*op and above:
Portuguese bullfights ('touradas')
take place from Easter to September.
The bull is not killed in the arena.

The Iberian Peninsula is, par excellence, the home of bullfighting. But here, as in many other walks of life, the Portuguese differ from the Spanish. The Portuguese matador does not actually kill his bull. The *touro*, symbol of animal ferocity since the time of the Ancient Greeks, is spared the coup de grâce in appreciation of an honorable opponent. In the eighteenth century the Count of Arcos was fatally gored, and the king decided the terrifying horns of the *touros* must be sheathed and blunted. Since then, this awesome ballet, with man and beast pitted against each other in move and countermove, has been a less violent and bloody affair. None the less, the passes and confrontations are still risky and intense.

At the start of the show the *cavaleiros* parade on the small, sandstrewn ring and line up facing the bulls. The *cavaleiros*, resplendent in shimmering satin, look for all the world like descendants of the old nobility who used to enter the lists against one of Nature's fiercest champions.

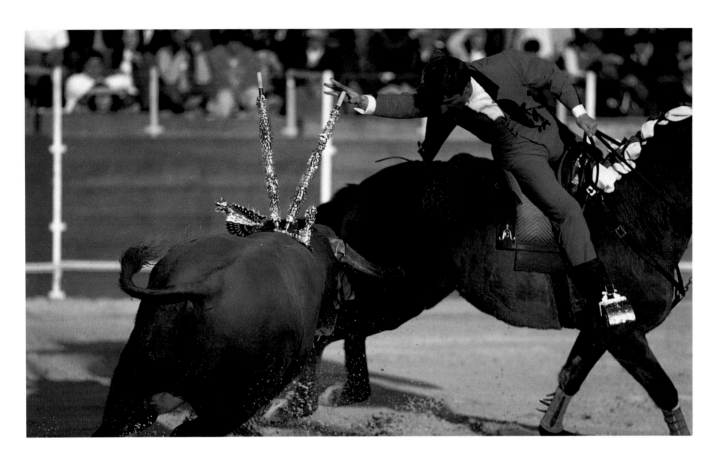

Above and overleaf: Everything happens at once: excited spectators find their hearts in their mouths for minutes on end as now the bull whirls round to charge, now the horse with his dashing and skilful 'cavaleiro' makes a deft wheel to safety. Judging his moment precisely to make a balanced and powerful thrust, the rider places his 'farpas' to signify victory.

• The *tourada* •

The combat is on: the performers confront each other, the spectators thrill to the action. After the *cavaleiros* have displayed their skill and daring, the eight *forcados* take over. A *forcado* is a kind of cowboy; *forcados* all wear the same beige, brown, or reddish costumes and take on the bulls bare-handed. One doughty *forcado* positions himself in front of the animal, defying it and inciting it to charge him. He launches himself onto its neck. Repeatedly the great bull tosses and barges him, but he must hang on desperately till his helpers can master it, usually by the tail. The first attempt is rarely successful, even if the bull has been weakened by the *cavaleiro*. Back they go again and again, despite the danger. *Noblesse oblige*, honour must be satisfied. Finally the bull is wrestled down. The successful *forcados* come forward to be acclaimed by the crowd as death-defying heroes.

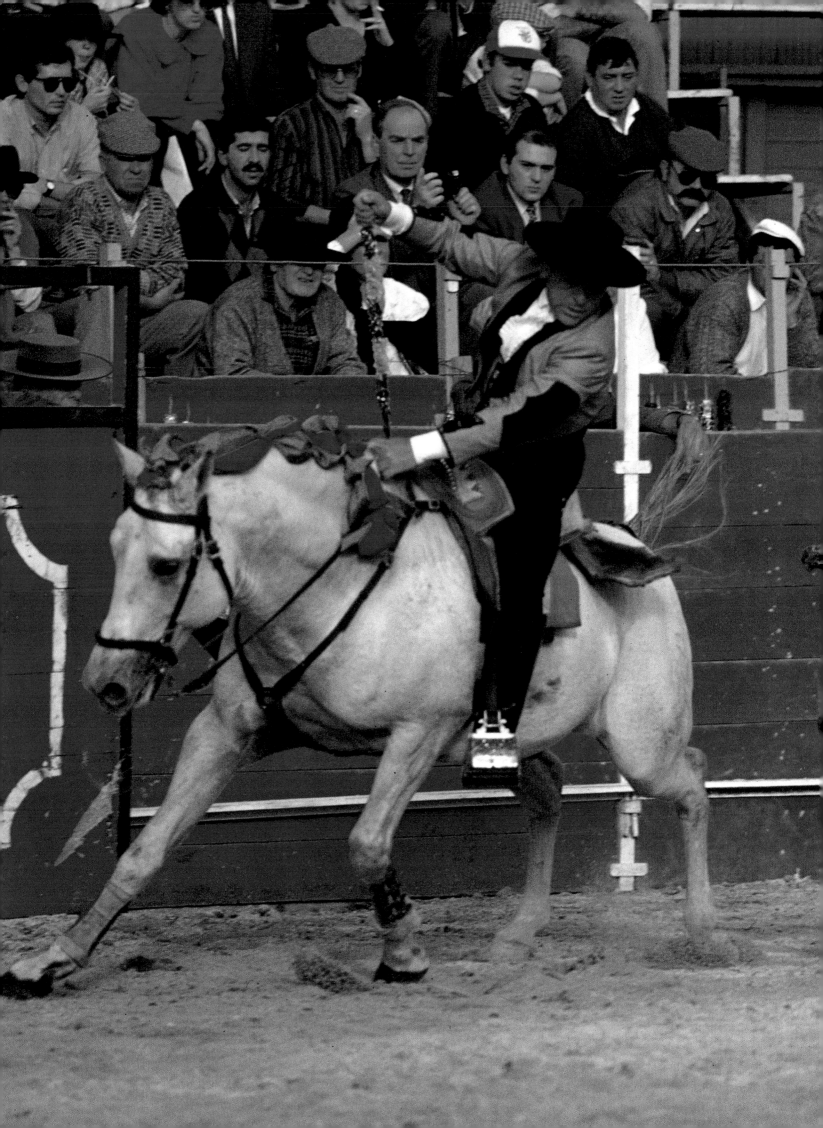

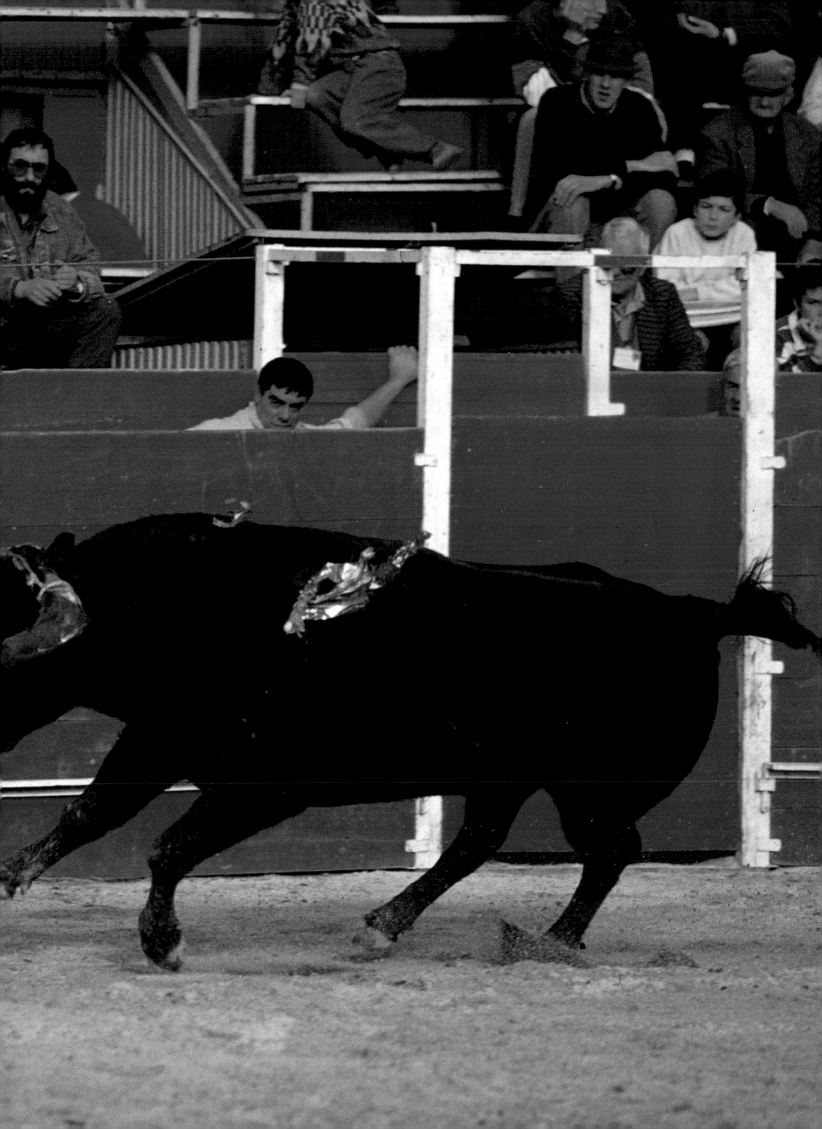

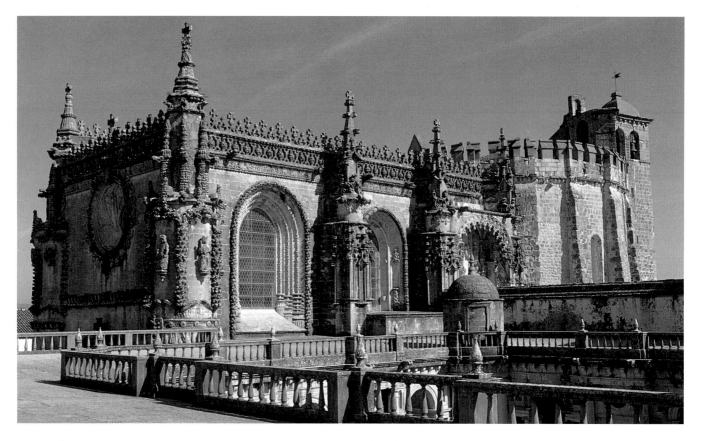

Above and opposite:
The Convento de Cristo, which
crowns a hill overlooking the town
of Tomar, is a sublime monument to
the blend of different architectural
styles which have characterized
Portugal through the ages.

TOMAR

A magnificent town for its art and history, Tomar is situated in the heart of Portugal. Through its centre runs the River Nabão, and it is crowned by the Templar Castle, in whose grounds stands the Convento de Cristo. The name of the town derives from that given by the Moors to the river where, today, the white houses of the community, laid out in neat, straight lines, are reflected in the water. The treasures which Tomar conceals are simple ones, far from the riches amassed by the Templars, who made this town their head-quarters and refuge. The natural setting is green and beautiful, with its wooded valleys, the lake of Castelo do Bode, the Seven Hills National Forest… The streets are cheerful with flowers, the gardens fragrant with roses and fuchsias, and there are fine seigneurial houses, churches and chapels such as the Capela de Nossa Senhora da Conceição or Santa Iria. All these things form the background to a satisfying and sophisticated way of life.

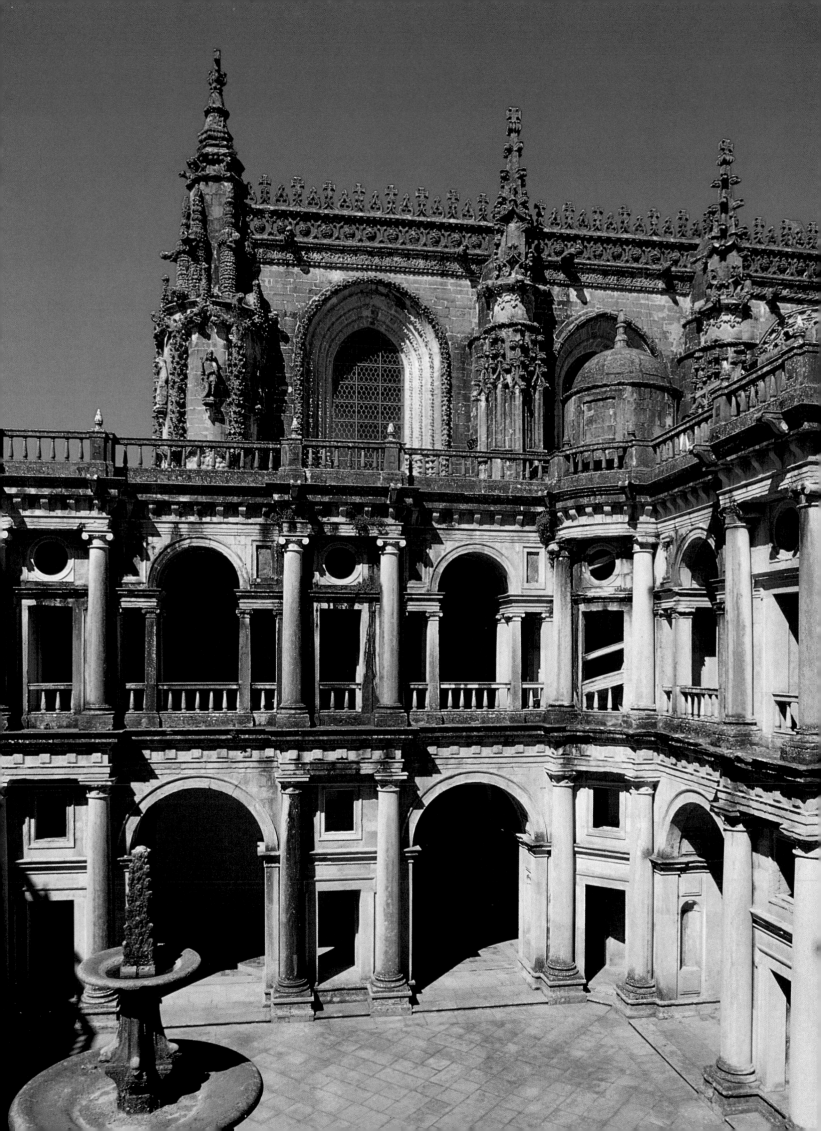

*A*bove: *Exquisitely carved Renaissance motifs from
the main entrance to the Convento de Cristo at Tomar. (Detail.)
Opposite: The Convent entrance with its wealth of decoration.*

• The Convento de Cristo •

The Convent of Christ at Tomar is one of Portugal's major architectural *tours de force*. The outcome of work which spanned the twelfth to the seventeenth centuries, it is virtually a microcosm of the country's successive styles. The original church was a rotunda (the *Charola*), built by the Templars in the twelfth century. The Gothic cloisters date from the era of Henry the Navigator – in the fifteenth century he was the Grand Master of the Knights of Christ, the Order of the Templars revived under a different title. The construction of the new church and its chapter-houses was ordered by Manuel I in the first half of the sixteenth century, while João III, who took a particular interest in this building, together with Philip II, eventually added new cloisters later in the same century.

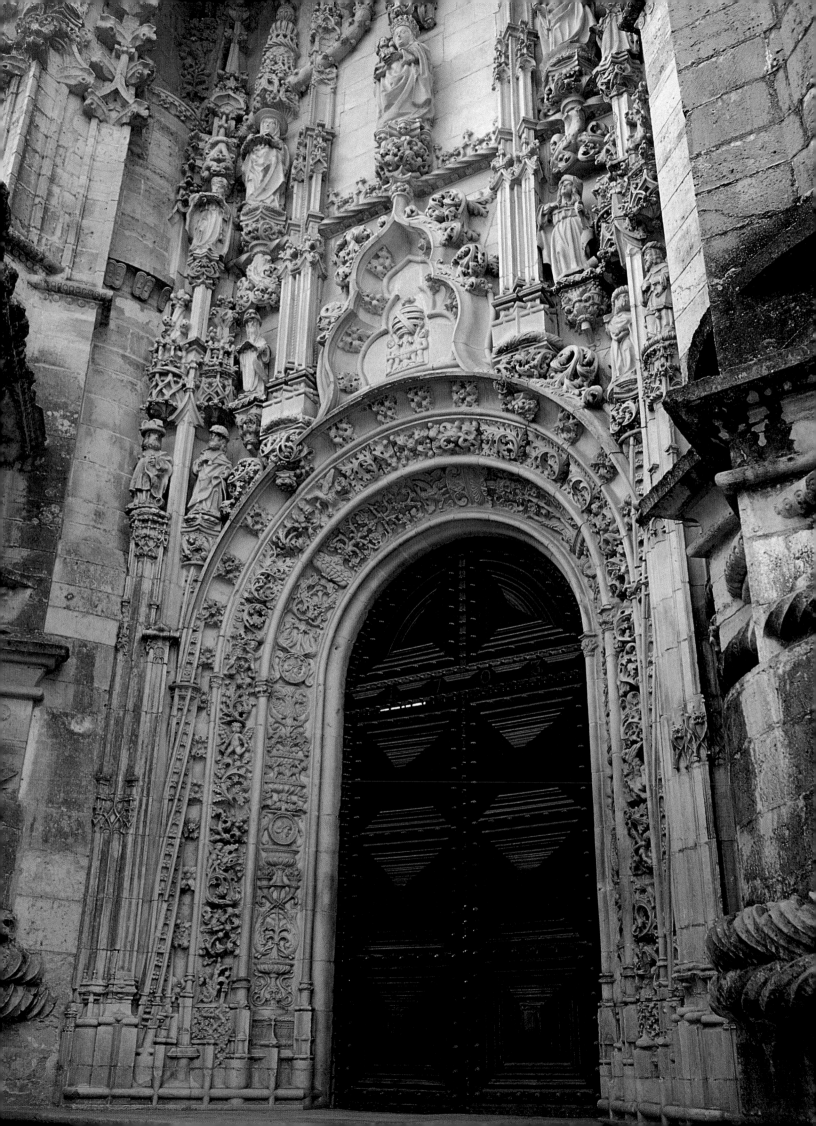

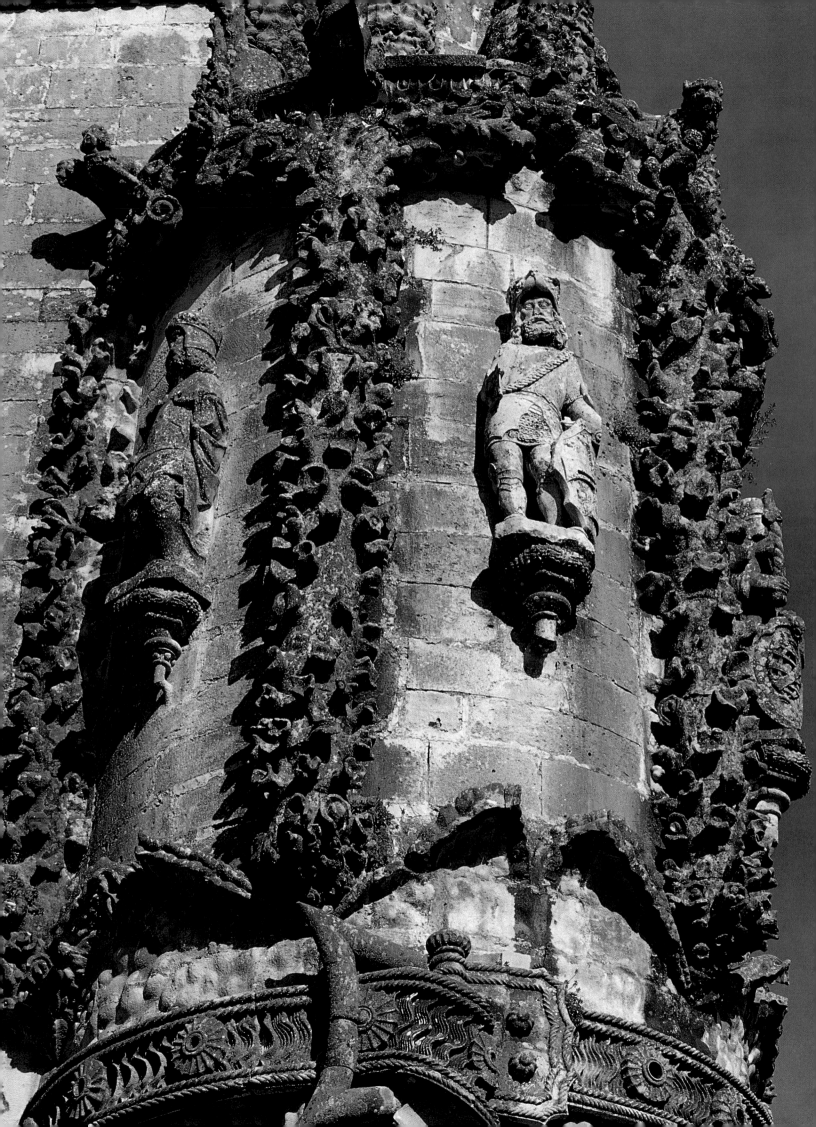

*T*op, bottom right, and opposite: Manuel I, known as the Builder, oversaw the construction of the new church and its chapter-houses. Decorations relating to the ocean and the voyages of discovery rub shoulders with heraldic devices and motifs symbolic of Christianity.

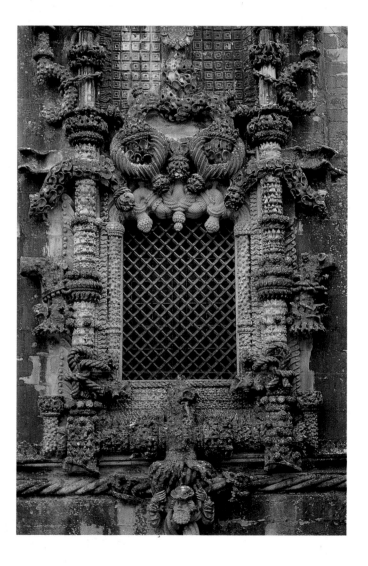

*B*ottom left: The famous Manueline window of the Convento de Cristo at Tomar (central section). This masterpiece of decoration is highly complex. A kind of rebus or visual allegory brilliantly typifying the Manueline style, the window presents the viewer with a profusion of nautical details: cables, cork oak, chains, nets, coral, buoys…

Above. The festival of the 'Tabuleiros', which takes place intermittently at Tomar,
is one of the most important events in the folklore calendar.
Opposite: The 'tabuleiros' consist of willow baskets supporting set-piece decorations more than 3 feet high
and weighing between 10 and 15 kilos (22–33 pounds). There are thirty loaves in the piles.

• The Festival of the *Tabuleiros* •

One of the most important Portuguese festivals is that of the *Tabuleiros* (platters), which takes place in July at Tomar at intervals of between two and four years. The *tabuleiros* are set-piece decorations 3 feet high and weighing 10–15 kilos (22–33 pounds), consisting of thirty loaves threaded on a bamboo framework, decorated with paper flowers and blades of wheat, and fixed in a willow basket. The *tabuleiros* are carried on the head by the young women of the town in memory of the advice given in the fourteenth century by the queen – St Isabel, the people's idol – to feed the poor. This act of charity is at the origin of the long procession in which the bearers, dressed in white, parade in two ranks along the street, each accompanied by a young man in a white shirt.

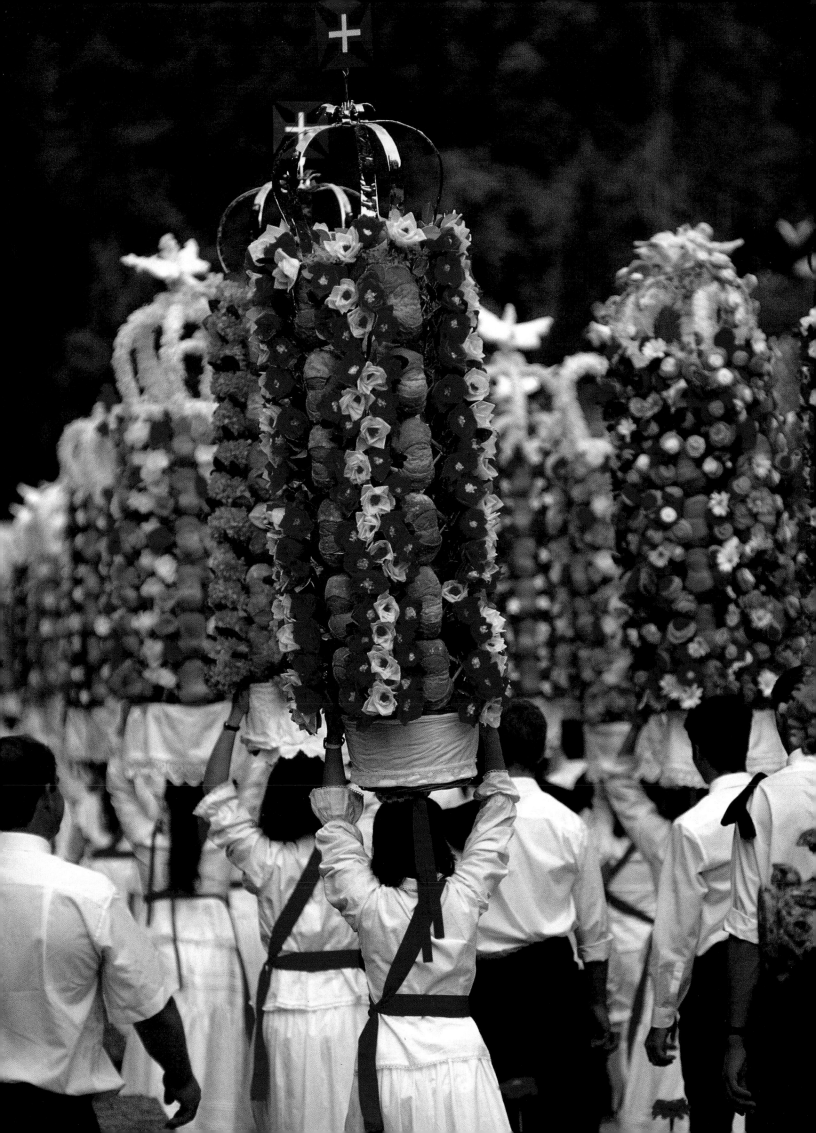

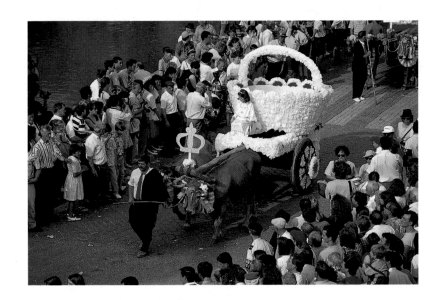

*O*pposite: The people of Tomar take evident pride in each enactment of their festival.
Top: In the role of St Isabel, innocence is crowned queen for a day. This young lady riding on a cart drawn by two oxen has a basket so big that it could feed all the poor on its own.

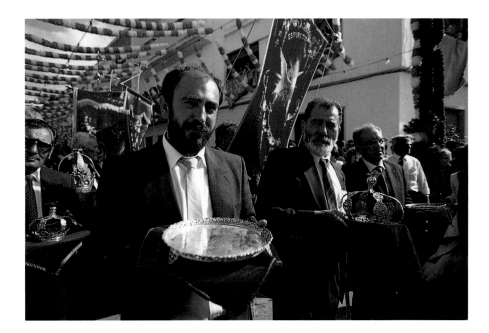

*A*bove left: Young water-carriers arrive to refresh the girls struggling under the weight of their 'tabuleiros'.
Above right: Preceding the 'tabuleiros' are the representatives of different towns and villages in the neighbourhood of Tomar, bearing platters and crowns – the emblems of their communities.

THE BEIRAS

The Beiras form a region between the rivers Tagus and Douro, to the north of Estremadura and the south of Oporto, bounded by the Atlantic coast and the Spanish frontier. The word 'beiras' means 'borders', and the area includes a whole variety of landscapes in central Portugal.

Opposite: Costa Nova is a pleasant watering place, where attractive and picturesque houses sport bands of brilliant colour. Here they make a bright contrast to this charming picture of youth and age.

In medieval times, the region of the Beiras made up a large province squeezed between the infant kingdom of Portugal in the north and the southern areas dominated by the Moors. The three divisions of the Beiras are: the Beira Litoral, the coastal region extending along the sedimentary plain of the Costa da Prata; the Beira Alta (High Beira), whose plateaux border the mountainous north-east of Trás-os-Montes; and the Beira Baixa (Lower Beira) with its plains stretching from the Serra de Estrêla – the principal chain of mountains in central Portugal rising to 1,993 metres (6,539ft) at its highest point – to the banks of the Tagus.

Of the three provincial capitals (Coimbra, Viseu, and Castelo Branco), Coimbra, sprawled over the Beira Litoral, is the most prestigious. A cultural and university centre unequalled in the country, it developed at the end of the last century along the flanks of a hill watered by the River Mondego.

This river was the old line of communication between the Beira Litoral and the sea. Today its waters still wash the city's two shores, and are the source of the phenomenal amounts of small stones

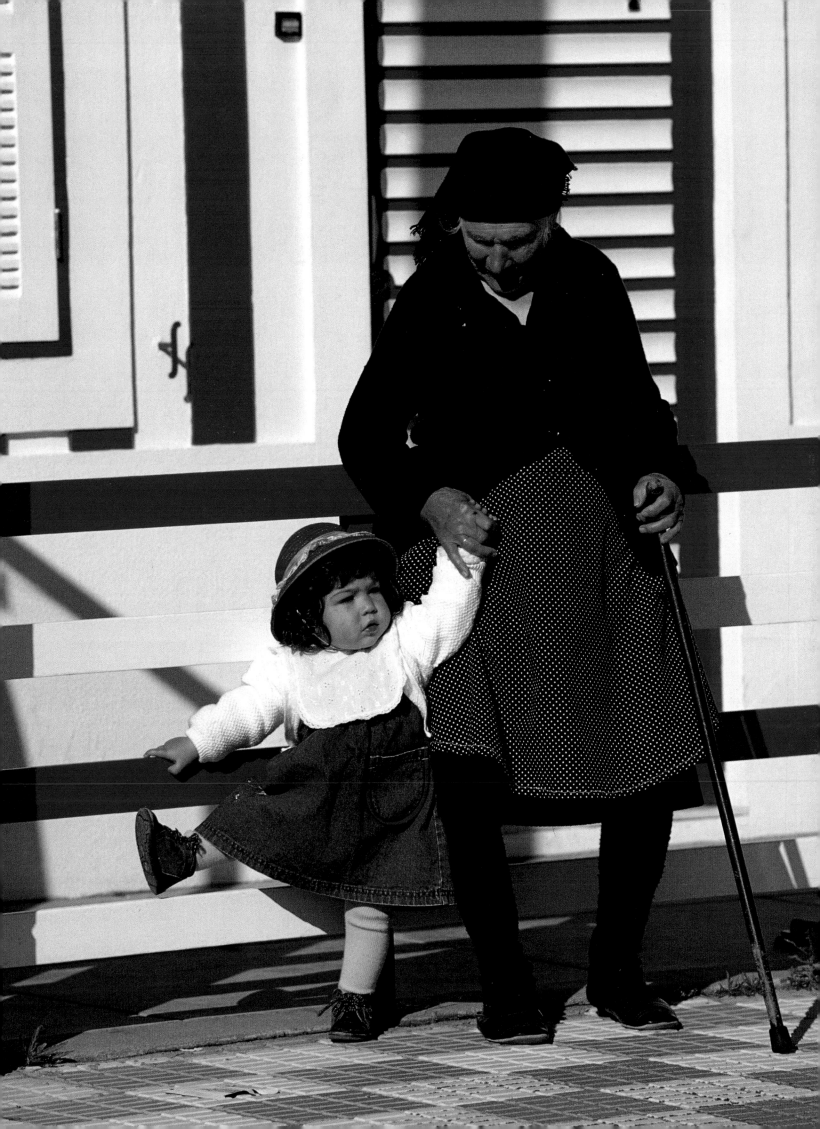

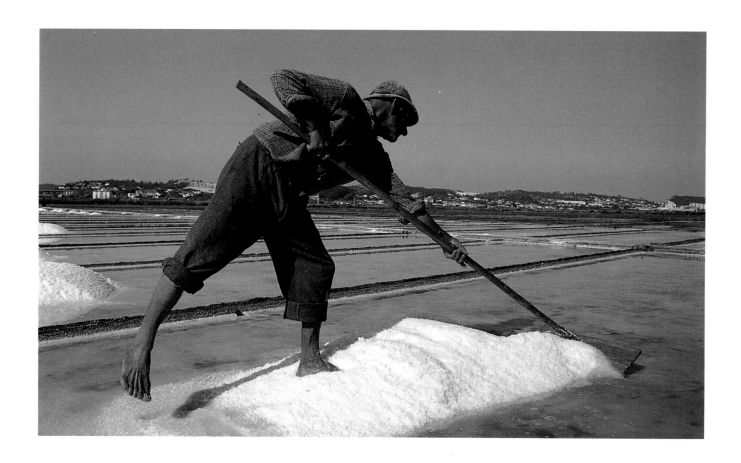

A̶bove and opposite: Along the Beira Litoral, especially in the Aveiro Lagoon,
harvesting salt is a traditional activity.

• The Aveiro Lagoon (*Ria*) •

Flooded fields, rice plantations, salt pans or beaches of fine sand: the Aveiro lagoon covers 6,000 hectares (23sq miles) at high tide. Urban life and commercial activity have developed continuously beside it for a century, ever since a passage was opened through the lagoon to the sea. Fishing for cod, sardines, and skate then made Aveiro's fame and fortune, before the exploitation of the salt pans, rice-growing, and the use of seaweed as fertilizer diversified traditional activities. The coloured boats (*moliceiros*) plying the gentle waters of the lagoon are painted with crude human or religious figures. They are used not only for fishing but to transport salt, seaweed, eels and every type of cargo.

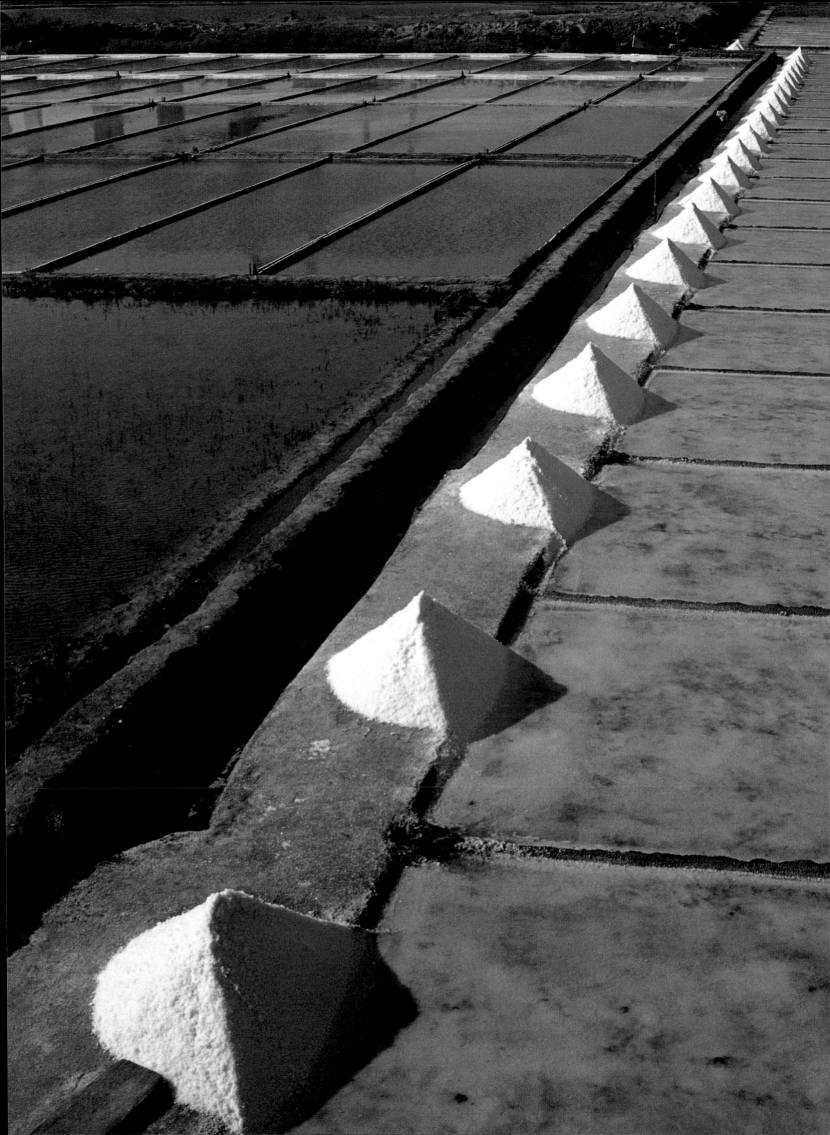

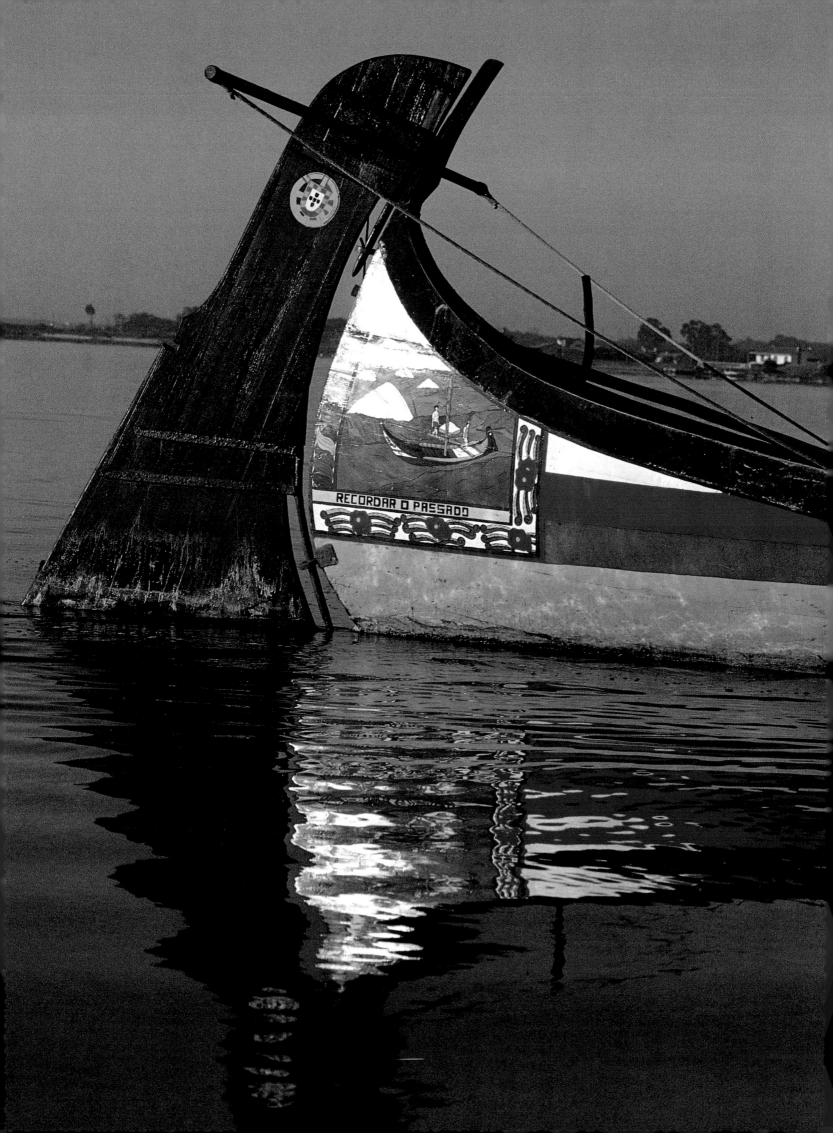

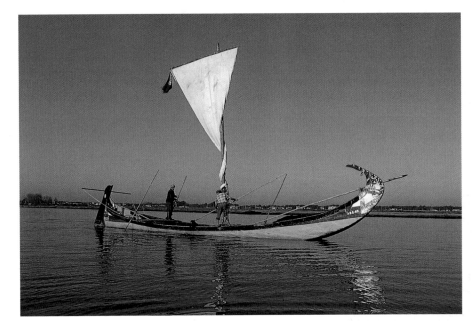

*T*his page and opposite: The vividly painted, swan-necked boats – 'moliceiros' – are one of Aveiro's curiosities and the gondolas of this Portuguese version of Venice. The name means 'seaweed boats'. Scenes from daily life or religious subjects adorn the prows and sterns.

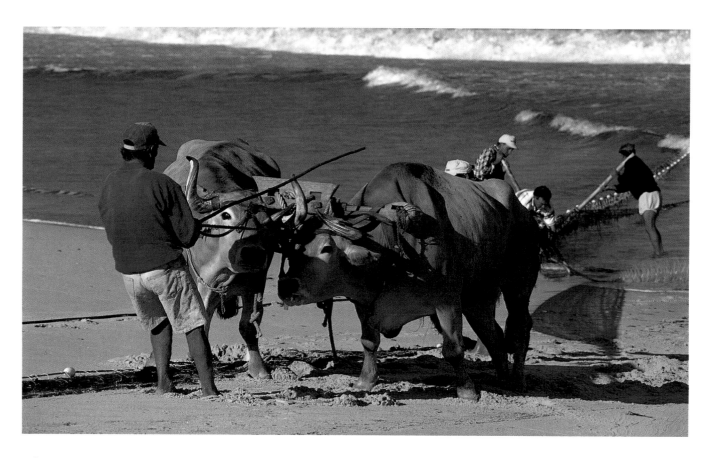

Above and opposite: On the Atlantic beaches, particularly at Torreira, the fishermen sometimes still use oxen to drag the laden nets from the water.

needed to pave the numerous city streets. These stones have a significant part of their own to play in the overall atmosphere and appeal of Coimbra. In particular, they have inspired many poets, some of whom have declared that anyone who has not tripped on these stones does not yet know Coimbra. Whether paving the labyrinthine alleys of the Lower Town or the steep slopes leading up to the famous hilltop university, the sheer variety of the polished stones – each with its own shape, size and appearance – emphasizes Coimbra's unique charm and the magic always lurking round the corner.

Henry of Burgundy had received the County of Coimbra from Alfonso VII of Castile after the latter had recaptured it from the Moors in 1064. His son Afonso Henriques then cut his ties with the tutelary kingdom of Léon-Castile and proclaimed himself the first monarch of the Portuguese-Burgundian dynasty, choosing Coimbra for his capital. From this moment on the city began to assume the character it now enjoys 850 years later and which

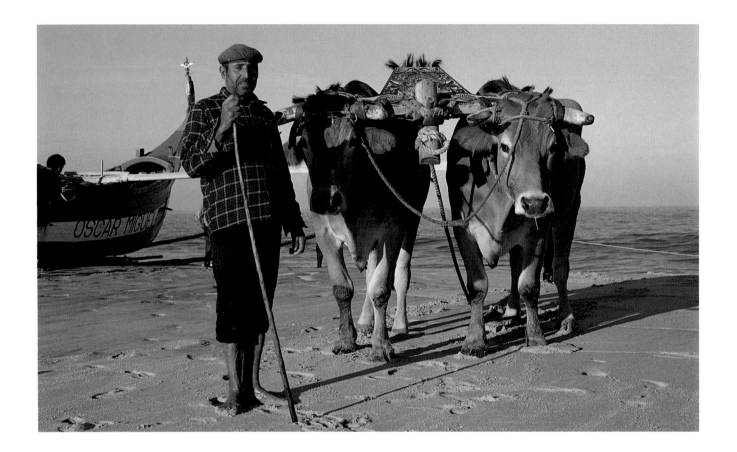

mirrors the spiritual, cultural, and political identity of Portugal.
The numerous monuments – Romanesque, Gothic, Manueline,
Renaissance, mannerist, baroque, or neo-classical – allow the vis-
itor an overview of the city's past developments and history. First
and foremost a royal town, it could not do without a palace,
churches, and a cathedral. In the mid-twelfth century, Afonso
Henriques ordered the construction of a sublime Romanesque
cathedral, the Sé Velha. Built of big blocks of yellowish-grey stone
which take on a mellow glow in the sunlight, it appears to have
emerged intact from the earth in all its fortress-like mass.
Dominating the cathedral since 1308, the University of Coimbra
powerfully illustrates through its continuous architectural devel-
opment the permanence of man's quest for knowledge. The great
Ceremonial Hall (Sala dos Capelos), converted in the seventeenth
century; the Sala do Exame Privado (Private Examination Room);
the Room of the Halberdiers, remodelled in the 1700s during the

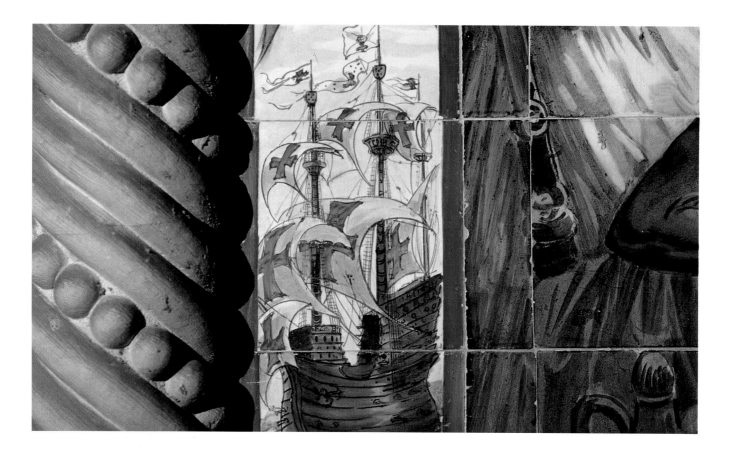

*T*his page and opposite:
The architecture of Buçaco Palace (now
the Palace Hotel do Buçaco), some
30 kilometres (19 miles) from Coimbra,
is highly refined, with twisted columns,
polychrome or blue and white 'azulejos
finos' illustrating the great maritime
conquests, and Manueline 'cloisters'.
Previous pages: On a hill dominating
the River Mondego, the city of Coimbra,
Portugal's earliest capital, remains the
country's cultural centre.

reforms of Dom Pombal; the university tower which is a seventeenth-century baroque construction; all these occupy part of the buildings of the former royal palace of Alcaçova belonging to Afonso Henriques. The only really important change in the university's approach to education over the course of 700 years was doubtless the abandoning in the last century of the requirement for students to study the humanities in Latin. Apart from this, university traditions have become even more engrained in that they are passed on from one generation of youngsters to another. Today, for example, students can still be seen walking about in traditional costumes worn under long, black capes, especially during the festivities marking the beginning and end of the academic year.

If Coimbra is a city where a youthful population, thirsty for knowledge, is constantly updating our understanding of the world, it also retains a strong attachment to religion. The azulejos of the Avenida Sá da Bandeira, representing the city's principal buildings, recall

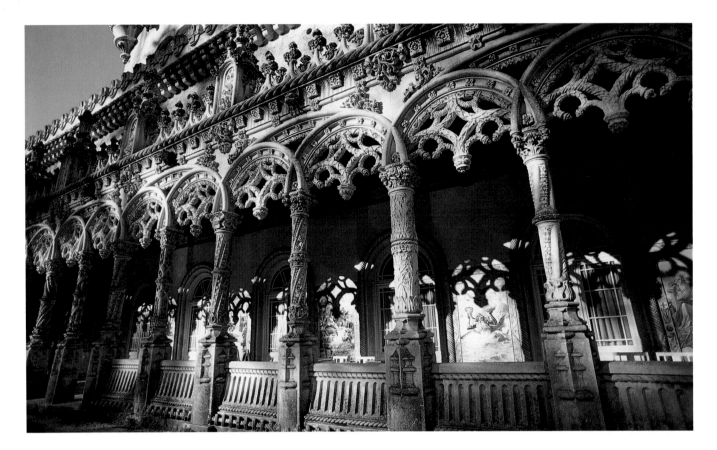

the importance of its churches. The religious fervour which inspired

the citizens of bygone days can be understood from a study of, for

example, the Convento de Santa Clara-a-Velha, the churches of São

Tiago and Santa Cruz , the Sé Nova – the cathedral built by the

Jesuits – the Convent of St Anthony of the Olives, the Celas

monastery, or the Sé Velha. Today this devotion centres around Santa

Cruz, on the Praça 8 de Maio, the main pedestrian thoroughfare.

This church is also noteworthy for the tomb of Afonso Henriques.

The only concession made to the modern age is that the old

side-chapel of the church has been transformed into a highly

unusual café. This café has an absolute ban on non-sacred music;

that is left to the few bars aimed at a young clientele, or certain

tabernas in the Lower Town, where one can enjoy the city's own

version of *fado*. Here the *fado* is sung only by men, unlike in Lisbon.

The *fado* of Coimbra, like the city, draws its inspiration from the

very wellspring of life.

*Overleaf: The Biblioteca Joanina
at the University of Coimbra. Its
construction was sponsored at the
start of the eighteenth century by
João V. Baroque in style, its walls are
lined with massive shelving.*

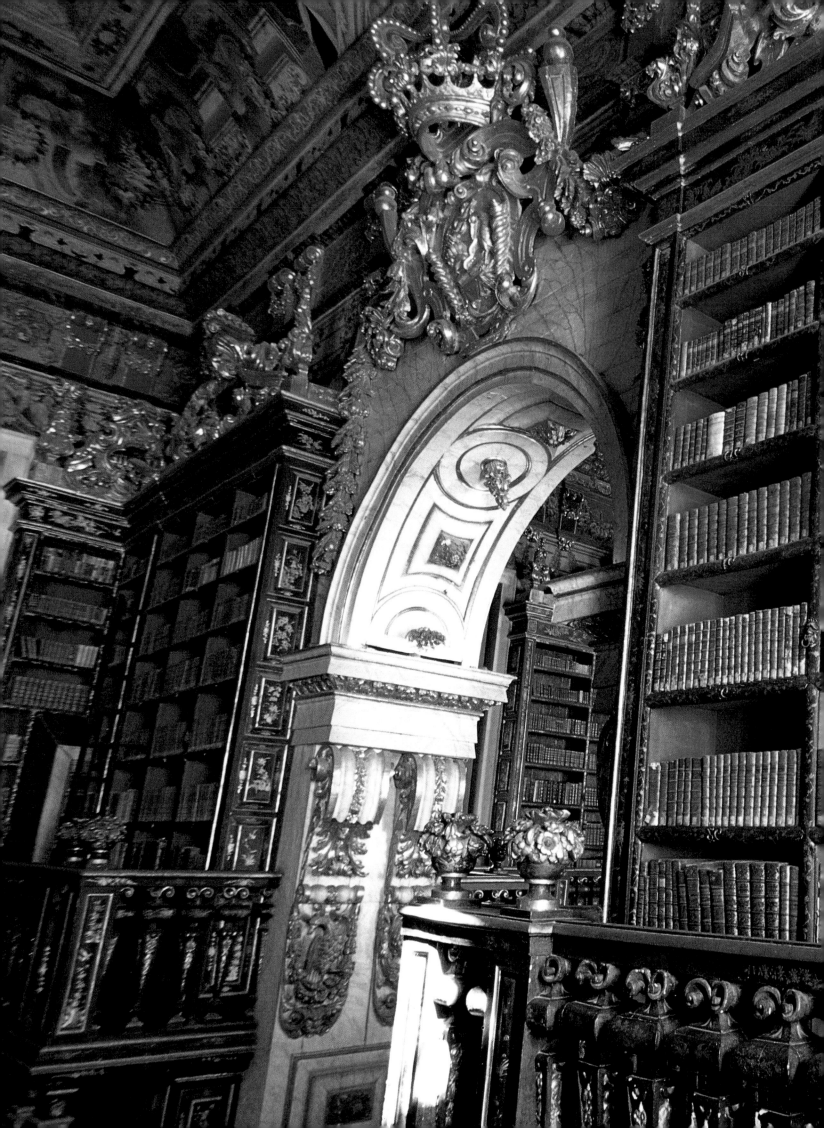

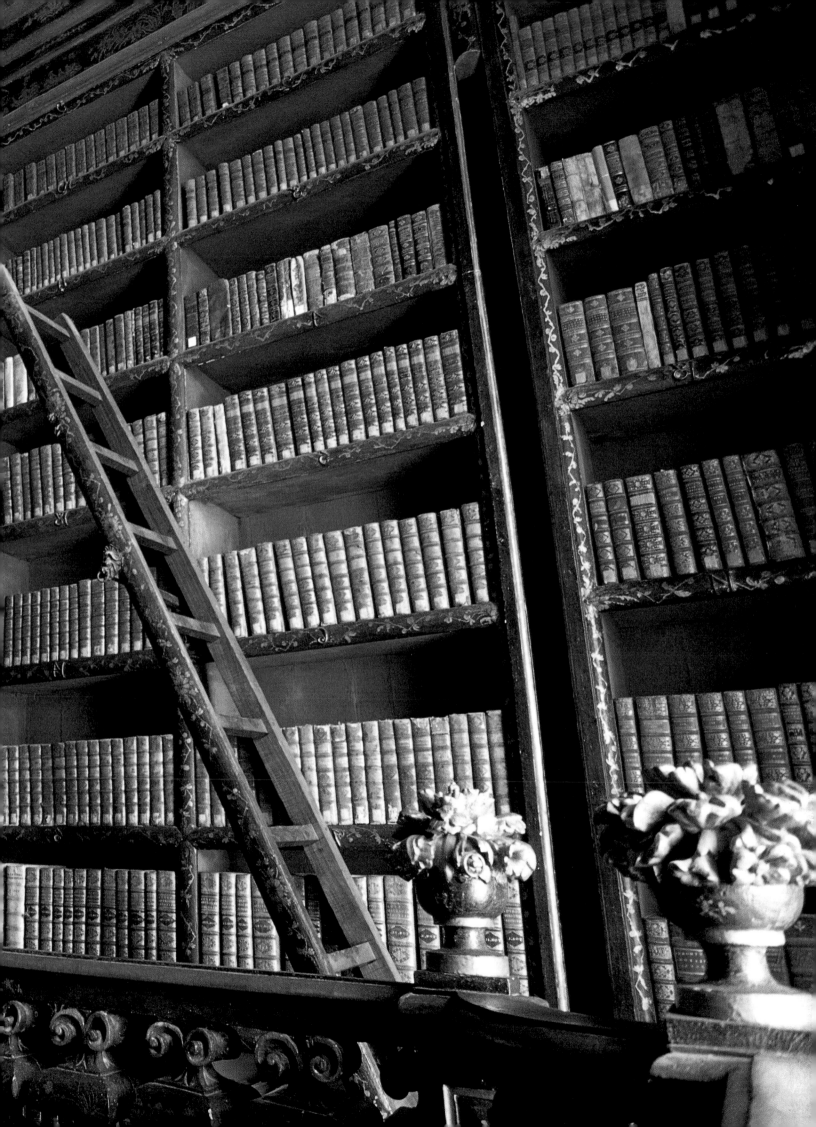

Oporto and the North

Oporto brilliantly bears out Victor Hugo's remark that the atmosphere of the city liberates the soul. Beguiling and puzzling, Oporto is indeed a free city as a result of its persistent sniping against the central authority of Lisbon and the latter's attempts to bring it to heel. A plucky city too, with its taste for hard work and its own identity.

Opposite:
On the slopes overlooking the River Douro rise the terraced vineyards which have made the Oporto district a household name.

There is no doubt that it is Oporto's people who have made the city what it is, generation after generation of them, since the time when the old County to which it belonged was the forerunner of Portugal. Oporto, in fact, has given the country its name; in this city are Portugal's roots, and its people are the nation's master builders. Stretching from the River Douro and its Atlantic coastline almost as far as its vineyards, the city has undergone amazing development, continuing to prosper due to the entrepreneurial spirit of its business community and the skill of its hardy workforce. Oporto stands on the two banks of the Douro estuary. Upstream the river waters the long valley, whose terraced hillsides give birth to their precious nectar: wine. Oporto's beginnings were on the right bank, on the steep hill which serves as its foundation. Here the people established the dwellings and monuments which make up its historic heart and enchant the most demanding visitor. Now listed as a World Heritage Site by UNESCO, the old city, which rises in the shape of an amphitheatre from the Cais (Quay) da Ribeira, can be

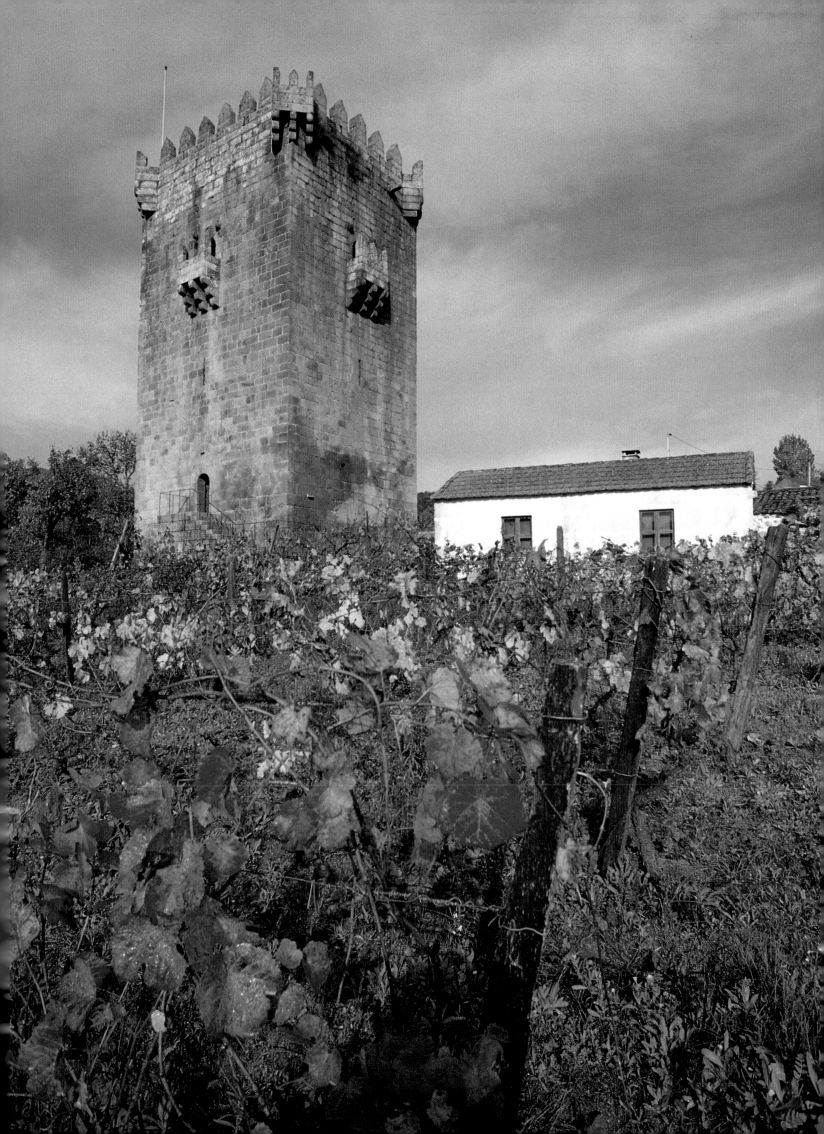

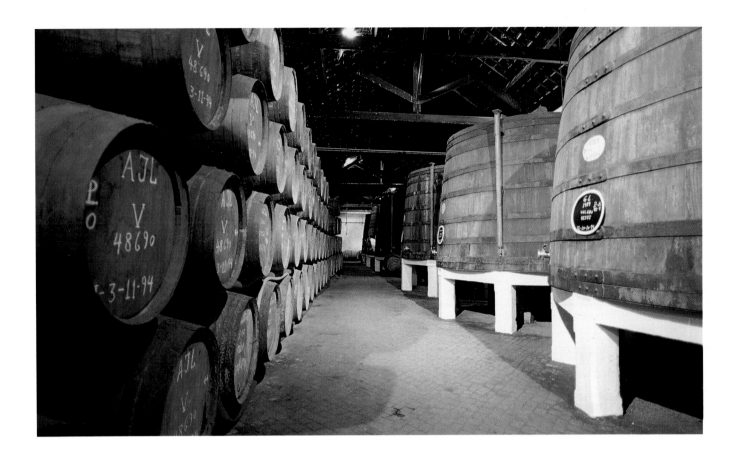

*A*bove and opposite: The reputation of port wine derives from the quality of the grapes and the region's excellent soil and climate. The wine can be aged either in bottles or casks. Those aged in wooden casks are the result of blending different vintages.

• Oporto and Port Wine •

At Villa Nova de Gaia, on the side of the Douro estuary facing Oporto, stand the famous port lodges, which can be visited. In the early eighteenth century the great family wine firms from England moved into the Douro valley to exploit the trade in this newly discovered nectar. Now, with the increasing costs involved in the production of port, family businesses have gradually been supplanted by international conglomerates. But the secrets of wine-making and the time required to produce a good port remain the same. 'Tawny' port is a blend of years, and sometimes of reds and whites. Different years are also blended to make 'Ruby', though it requires less ageing. 'Vintage' is early-bottled port from a single vintage. In making port, the initial fermentation of the grape-juice is arrested by 'fortifying' it with brandy, leaving the natural sweetness of the grape-sugar.

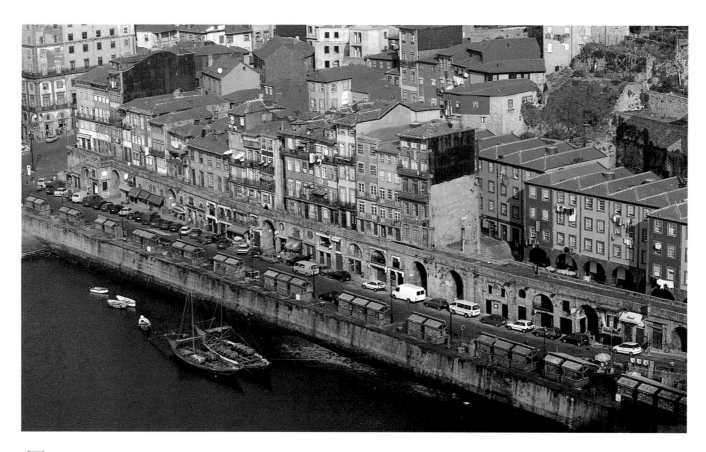

*This page, opposite, and overleaf:
The town of Oporto rises on the
right bank of the Douro, starting
from the Cais (Quay) da Ribeira,
which is the basis of the popular
quarter, now listed as a World
Heritage Site by UNESCO.*

admired in its entirety from the vantage point of the Serra do Pilar monastery on the left bank, near the famous steel bridge named after Dom Luís I and built by an assistant of Gustave Eiffel. The view from there is amazing: one's first glimpse will be treasured as a moment of delight and magic. Perhaps the birds have the best view of all of the glorious scene below: the palette of colours smiling cheerfully from the walls of old houses; the countless mosaics – golden-yellow, white, green, red, mauve or faded blue – enlivening the three, four, even five storeys of the ancient buildings on the Ribeira; the orange of the square, flat tiles high up on four-sided roofs; the regular patterns of windows with washing drying on lines; the towers of the churches and monuments standing out against the solid backdrop of bustling houses; the crenellated wall, an imposing relic of the medieval era, which still guards one flank of the hill; the green waters of the Douro flowing peacefully between their banks. Similarly, walking the switchback streets of

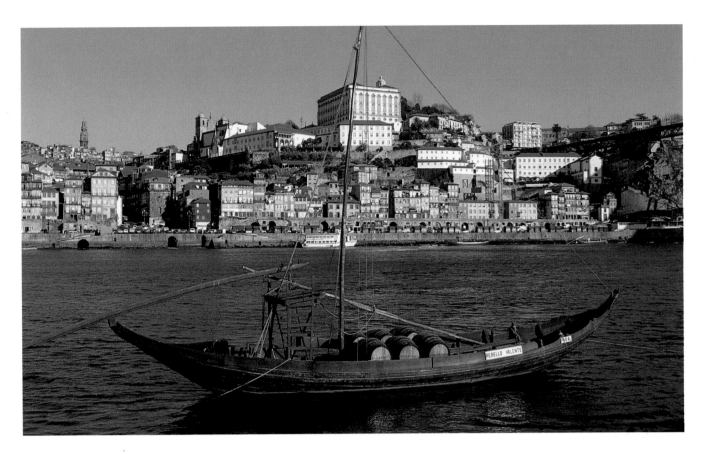

Oporto's escarpment will reveal views little short of sublime. Again and again parts of buildings suddenly spring into view, with the curious illusion of being present in their entirety.

The result of the huge variety in architectural styles, types of urban layout, and responses to the contours is that Oporto has a unique atmosphere and a soul all its own. A city of panoramic views, churches and seagulls, a living heart beats just beneath its stones.

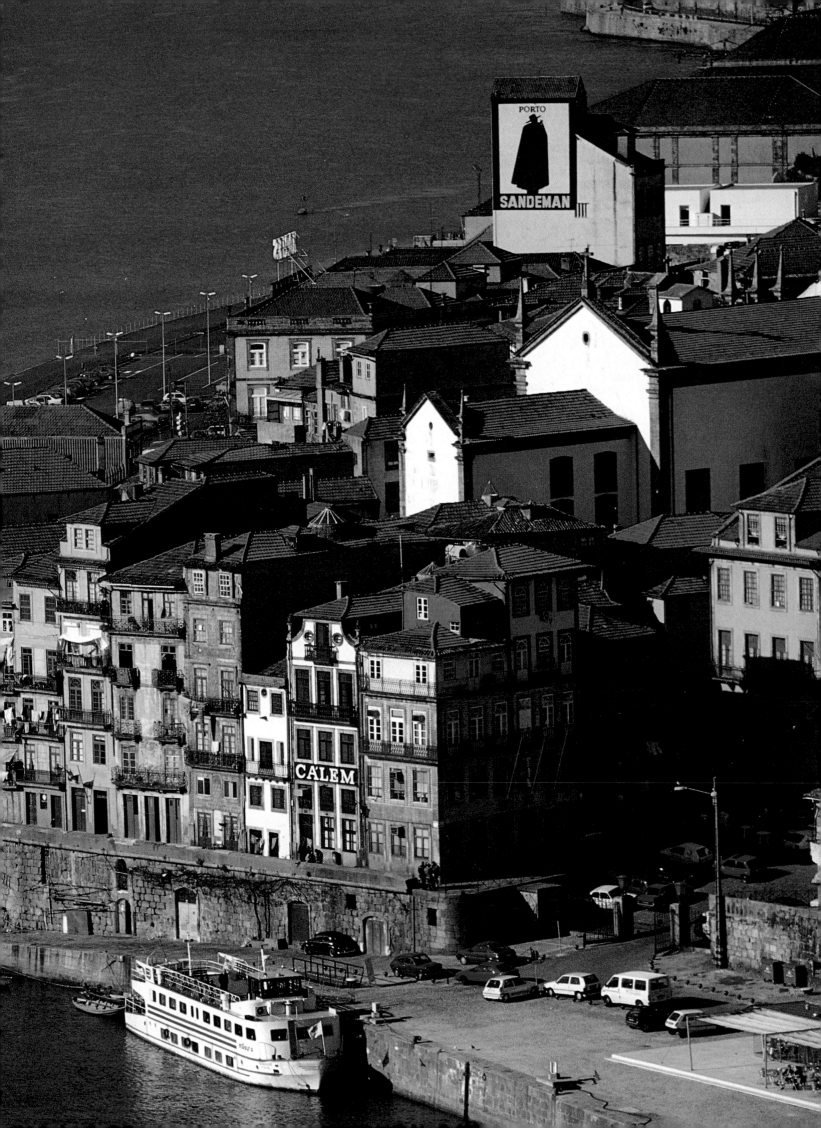

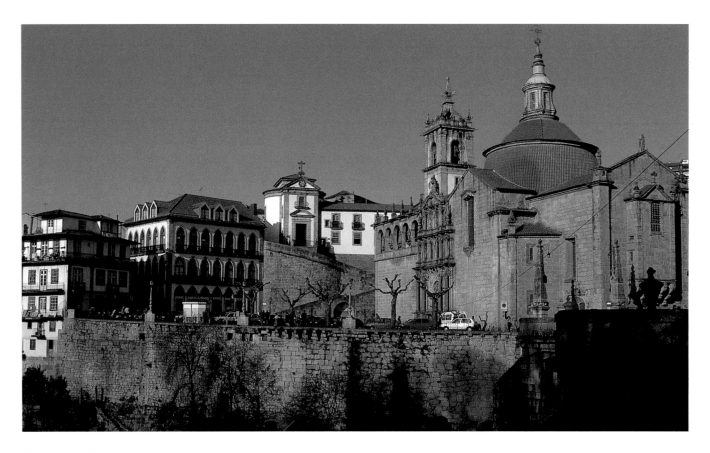

*T*op:

The church of the convent of
São Gonçalo at Amarante, constructed
in the latter half of the sixteenth
century, with its unique cupola.
Above: In the north of Portugal, old
traditions are still very much alive.

If the north and south of Portugal are diametrically opposed in the geographical sense of climate and relief, the various regions which make up the north also have distinct identities. For example, the overall area of the Costa Verde (the 'Green' Coast), consisting of the provinces of the Minho and the Douro, is hilly, well-watered and fertile. In this it clearly differs from the rugged and mountainous province of Trás-os-Montes, its close neighbour.

Undoubtedly the garden of Portugal, the Costa Verde contains landscapes of intense beauty with its blend of green valleys, wooded hills, and vineyards. Yet if it is the cradle of Portugal, it is also the homeland of the country's most industrious workers. Small in extent, this north-western territory is squeezed between its Atlantic coastline and the mountainous arc bordering it to the east. It is favoured with an ocean climate, and brings together a population with a traditional and deeply rooted sense of regional loyalty. Once a fief of Afonso Henriques, the first king of Portugal, who extended his kingdom

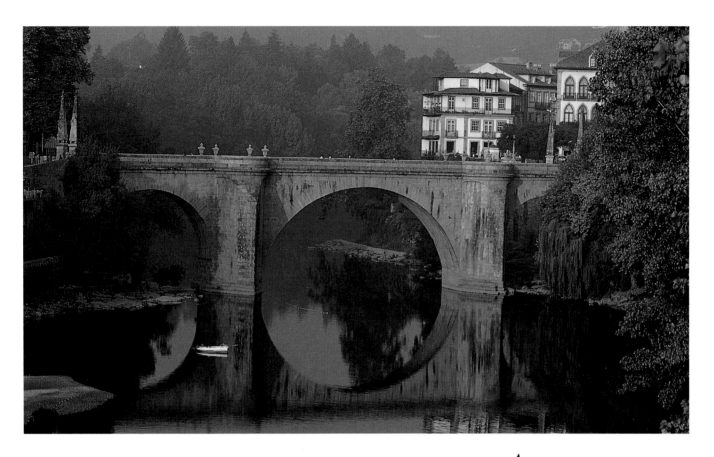

towards the south during the twelfth century, these valleys and

granite hills have in fact given birth to a lifestyle devoted to work,

the family, and the Catholic religion.

People are very fond of quoting an old saying that 'Coimbra sings,

Lisbon enjoys itself, Oporto works, and Braga prays'. Such a bold

assertion, seemingly overcredulous of folk traditions, is a sure way

of rekindling ancient rivalries between the main Portuguese towns

– yet it is still pertinent today. Oporto, for instance, the only real

regional capital in Portugal, has a sphere of influence extending

over the whole area of the Minho, the Douro, and the Beiras due

to its intense and thriving industrial and commercial activity.

Unlike Lisbon, Oporto, though an urban agglomeration, lives in

easy harmony with its densely populated rural environment. Its

economic influence as a regional capital is very important, and the

city enjoys a high standard of living, based on its traditional skills

and know-how. Braga, the capital of the Minho and the second

Above:
The Ponte de São Gonçalo
crosses the Tâmega at Amarante.

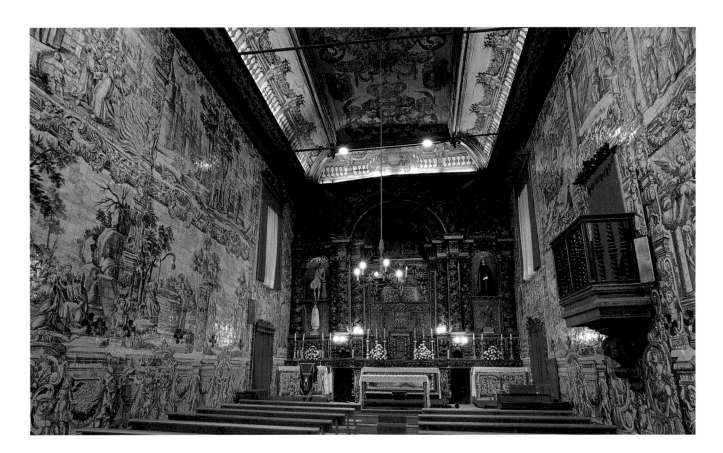

*T*op:
The Misericórdia church at Chaves possesses an unusual feature: its interior is covered with azulejos. Above: Old frescoes discovered beneath the plaster of a church by the priest of a village near Vila Real.

most influential city of the whole Costa Verde area, owes its reputation chiefly to its religious conservatism – as we saw from that old saying. The very Catholic Braga is both a university city with a very large student population, an urban middle-class centre operating a wide range of businesses, and a charming place to live, where the quality of life is paramount. Nicknamed 'The Rome of Portugal' or again 'The City of the Archbishops', Braga, rich in ancient memories and ecclesiastical heritage, is today Portugal's principal centre for religious studies. This enthusiasm for religion is revealed not only by the large congregations divided amongst its baroque churches, but also by all the small shops devoted to religion and the glory of God.

Braga is a prosperous city, full of wisdom and good taste. It is also spacious and harmonious. Numerous squares, each quite distinct, give the historic heart of the city room to breathe, setting off its character. In particular the large pedestrian areas are a great asset

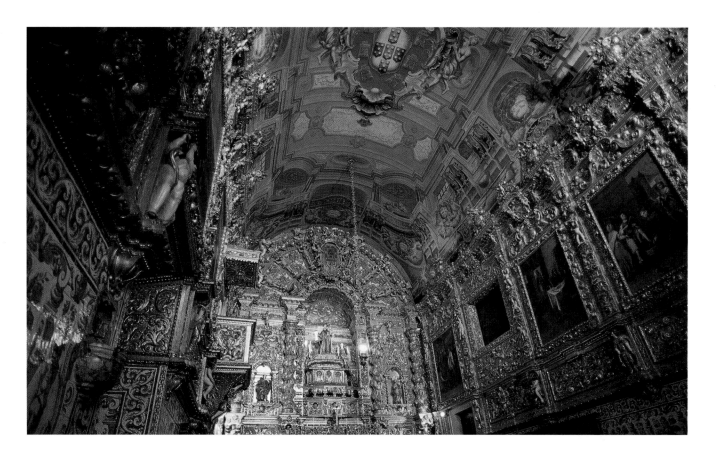

for the visitor wishing to appreciate the sights. The central avenue, for instance, with its huge, green space free of vehicles, has an atmosphere of rural calm. There are plenty of trees with their coiffe-like topiary, and dozens of public benches allow one to savour a moment of tranquillity. In the centre of this avenue a church with a sturdy, upstanding facade booms out its chimes every quarter of an hour. From the Praça da República a very fine view takes in part of the surrounding hills, grassy and wooded, which give the impression of walls enclosing the city. This viewpoint perfectly illustrates what makes Braga so unusually green and spacious. It also allows a glimpse of the monument serving as a landmark for the area round the city: the Sanctuary of Bom Jesus do Monte. Set 400 metres (1,312ft) up, the Bom Jesus, now a building of (renovated) neoclassical design, was a place of pilgrimage from the fifteenth century. From here one can enjoy a spellbinding vista extending to the shoreline of the Atlantic.

Top and above: Braga Cathedral. The paintings, gilding, chandeliers, and baroque decoration express the glory of God. It was felt His abode should surpass all others in splendour.

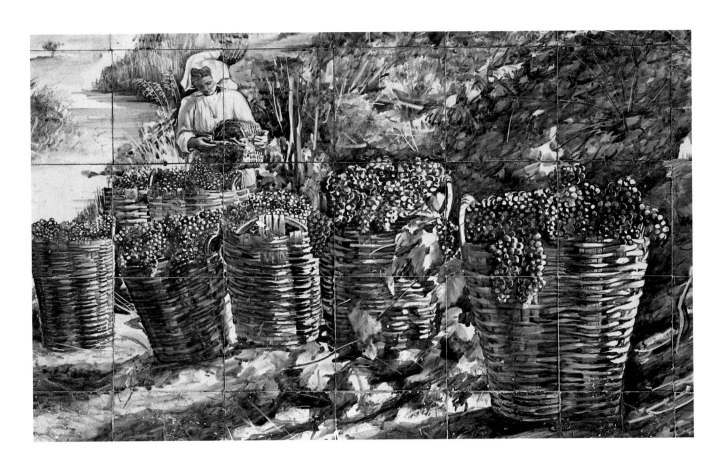

*Above and opposite: Delightful azulejos at Pinhão railway station,
with scenes from the grape harvest.
Overleaf: The superb decoration of the Basílica de Santa Luzia near Viana do Castelo.*

• The North-West: Heart of the Nation and Garden of Portugal •

The north-west was the cradle of Portuguese civilization: Henry of Burgundy and his wife Tareja made Guimarães the capital of their County of Portugal in 1095, and, more importantly, it was from here that their son Afonso launched his attempt to reconquer the territories occupied by the Moors. The region – notably the Minho – has always been considered the home of the country's founder and the heart of the nation.

It is also a region with qualities all its own. Geographically, historically, and in human and artistic terms, it forms a homogeneous entity, vibrant with life and character.

The luxuriant vegetation set against a backdrop of trellised vines, the steep hillsides providing homes for scattered but thriving centres of population, the smiling countryside with its strong religious associations, make the north-west truly the Garden of Portugal.

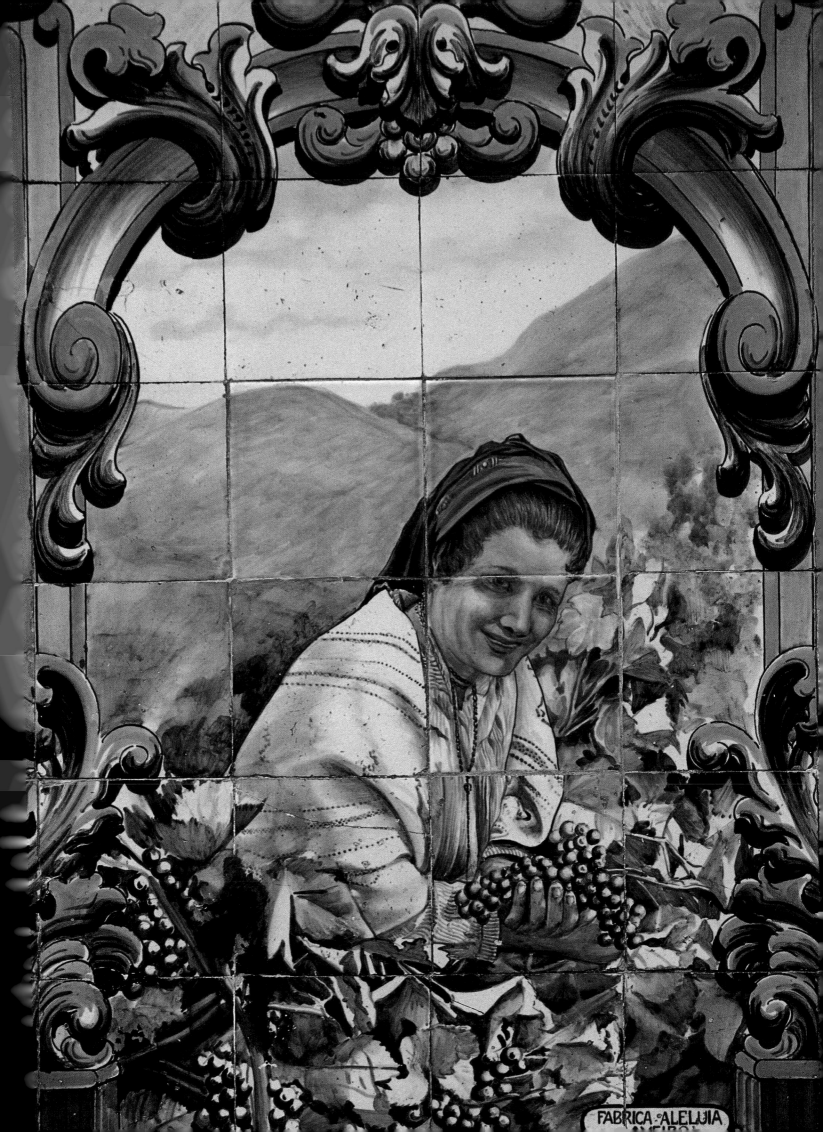

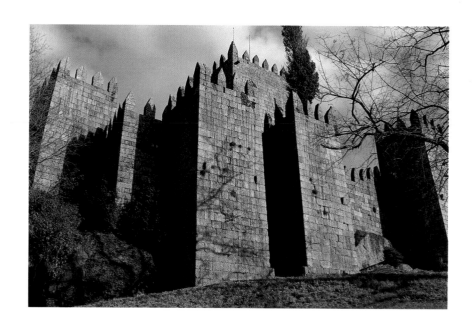

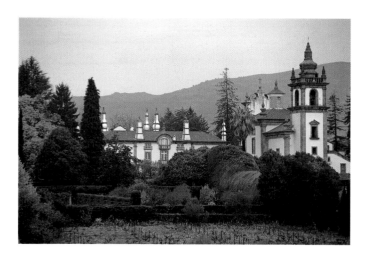

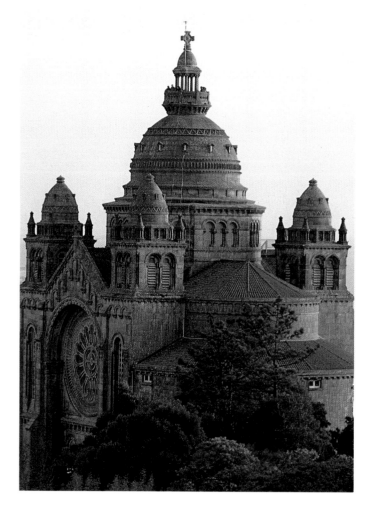

*T*op:
The castle of Guimarães has stood in
all its majesty and power since the
tenth century, 200 years before the first
king Afonso Henriques, who grew up
here, began the reconquest of
present-day Portugual.
Above, left: The Palácio de Mateus near
Vila Real. The mountains and hills of
Trás-os-Montes appear in the background.
Above, right: The Basílica de Santa Luzia
rises above the broad bay of
Viana do Castelo.
Opposite: The collegiate church of Nossa
Senhora da Oliveira in Guimarães.

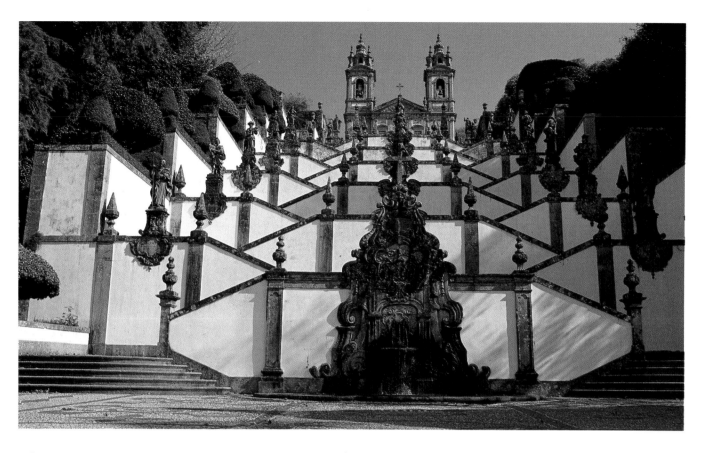

*S*et 400 metres (1,312ft) up not far from Braga, the Sanctuary of Bom Jesus, now a building of (renovated) neoclassical design, was a place of pilgrimage from the fifteenth century. Rewarding the visitor is a staggering vista stretching right to the shoreline of the Atlantic.

One may choose to head for the south and Guimarães, the earliest Portuguese capital, a fine, flourishing city with well-preserved buildings. Alternatively, there are the superb beaches of Esponende to the west or those further north around Viana do Castelo. But in every direction hills and valleys succeed each other, clothed with vegetation and trees of every hue of green. The countryside is dotted with clumps of granite-built houses, proud and solid-looking, and at irregular intervals small towns draw into sight. Everywhere the eye catches some revealing glimpse of the rural scene: countless lives lived out according to changeless traditions, hard existences unrelieved by the arrival of the modern era. Old women push or drag barrows full of vegetables along the main roads; there are farm workers stacking sheaves; hardy menfolk driving their old, red tractors in every kind of weather, holding umbrellas over their heads when it rains; members of the older generation busy around the family home – part farm, part country house; a grandmother

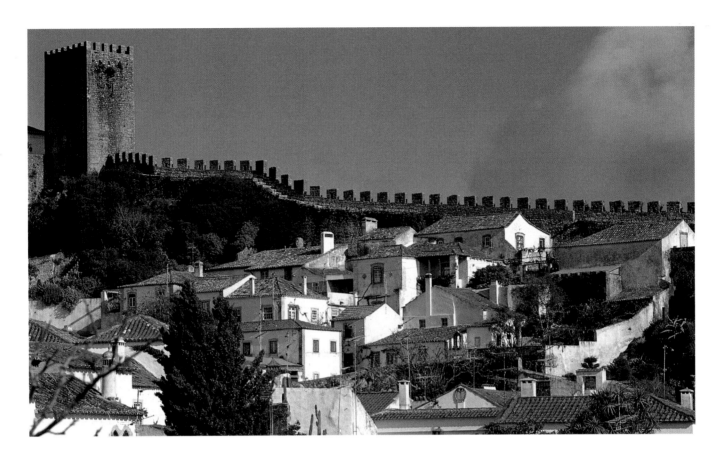

with two of her grandchildren off to the beach to fill big pails with sand for her garden.

The older people of the north are particularly impressive. Having seen the old days, they remain guardians of tradition, preserving intact the values of hard work, discipline, and respect for oneself and one's neighbours. This is perhaps truest in the mountainous north-east, where geographical isolation has not yet been overcome as it was in most other rural districts in the years following the Carnation Revolution.

Certainly it is the case with the people of Trás-os-Montes, of which Vila Real is the economic capital and Bragança the administrative centre. They make a deliberate point of carrying on in their old, traditional ways. The Portuguese author, Miguel Torga, writing of his country, conjures up a picture of these people, whom he clearly admires: 'The folk of this curious little kingdom – Trás-os-Montes – are incapable of obeying instructions from the outside world,

Like Óbidos in Estremadura, many villages in the Alentejo were given fortifications in the distant past, including Monsaraz and Marvão.

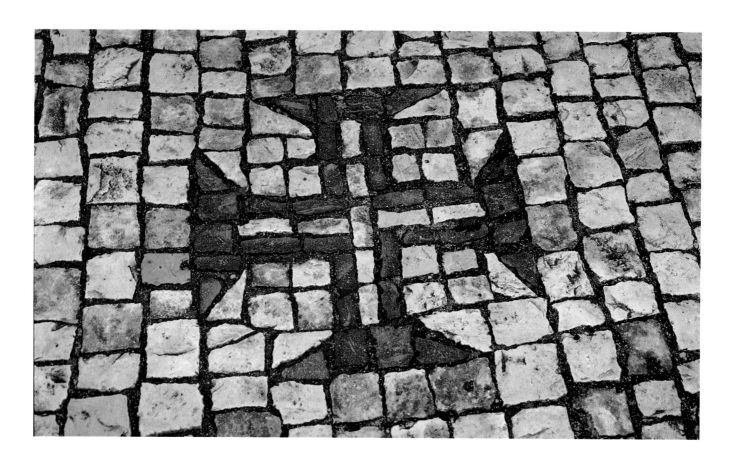

Above:
The Cross of Christ depicted in
Portugal's famous 'dragon's teeth'
paving stones.
Opposite: The facade of a solid, old
church typical of the Alentejo.

considering as natural and legitimate nothing but the dictates of their own consciences. The distant echoes of commands foreign to their inner sense of harmony glide over the outer surface of their minds without leaving the slightest impression.'

THE SOUTH

The south, with its Mediterranean climate, consists of two quite different regions: the Alentejo, literally 'the area beyond the Tagus' which extends from that river to the Serra de Monchique and the Serra de Caldeirão; and the Algarve, whose 150-km (94-mile) coastal fringe in the south is separated from the gently sloping plains of the Alentejo by these two rugged mountain chains.

Opposite and overleaf: In the Alentejo, inland landscapes are carpeted in the spring with highly scented flowers. The Mediterranean-style colour adds another touch to the magic of Portugal.

Entrenched within an endless series of large estates, the Alentejo is a region of plains and valleys dotted with cork trees, olives, and holm oaks. It is also scattered with small, fascinating towns rich in history and tradition. Quite unique to the country, covering an immense area on the Spanish border, it is essentially the chameleon of Portuguese landscapes. Carpeted in spring with highly scented flowers, an unrelieved brown ochre with the onset of winter, in summer the Alentejo assumes the golden hue of its wheat, before consuming itself in the rays of a scorching sun. The Mediterranean colours of these inland landscapes add magic to the spirit of Atlantic Portugal, concentrating thought and monopolizing one's attention. A monotonous and boring place for some, with its one vast succession of unfenced properties, and a demographic desert for others, who have seen so many of its sons depart to the industrial areas of the coast or emigrate abroad, the Alentejo is in reality an ocean

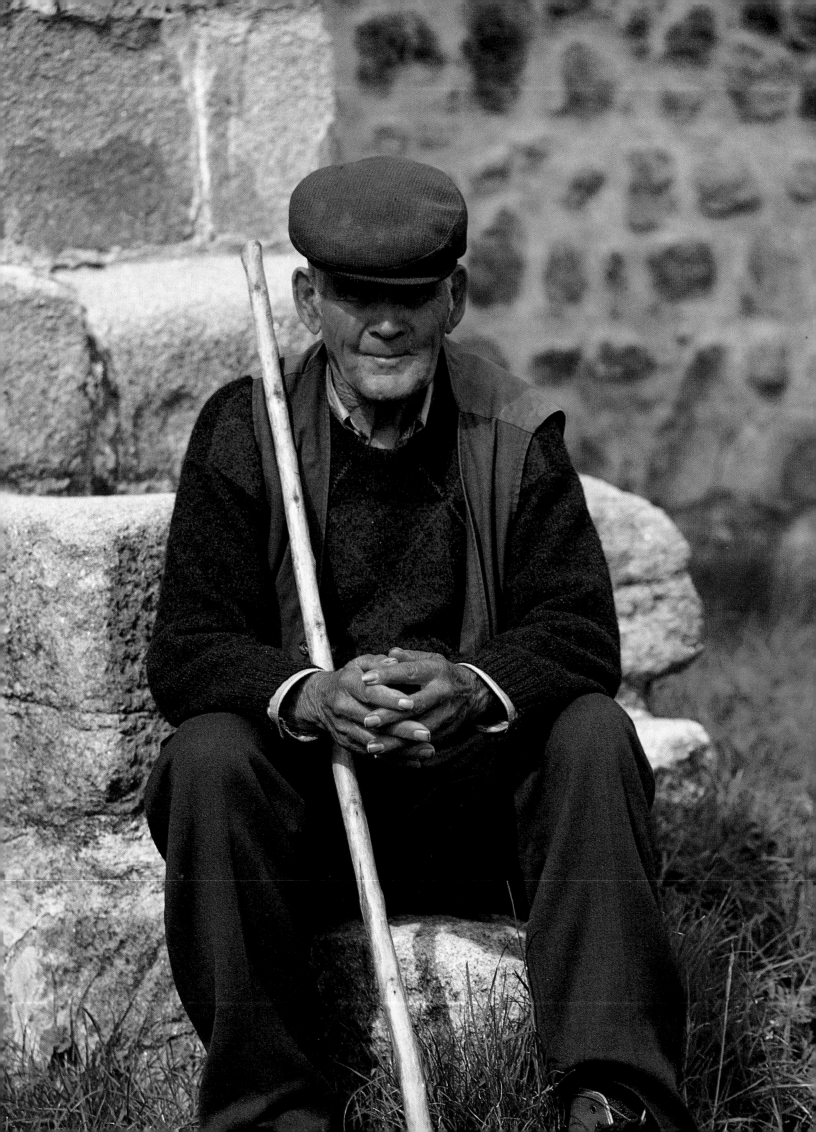

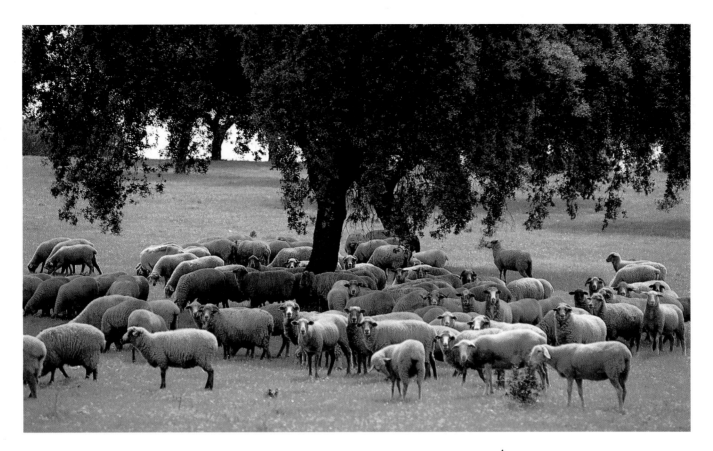

of delights. And indeed, as on a sea, the crowns of the cork oaks stir like wave-crests at the whim of secret and mysterious winds.

These winds are felt with a very real intensity on the dozens of hilltop *miradouros*, where splendid towns were fortified in the days of old. Like cliffs or promontories thrusting out toward the immobility of sea and sky, there are locations on the walls at places like Évora, Estremoz, Monsaraz, Castelo de Vide, or Marvão where one can enjoy incredible panoramas and experience the wind in all its elemental power and ceaseless motion. From the historic centre of Estremoz, for example, especially from the top of the Vauban-style fortifications, numerous viewpoints reveal the generosity of Nature, who, here, is ever warm and welcoming. In summer her coat of many colours glows fiercely under a clear and brilliant sky, reflecting but fleeting gleams of sunlight as the autumn wanes. The light also throws the regularly whitewashed houses of Estremoz into striking prominence. The white marble of the medieval quarters is

Above and opposite: On the large properties which make up the rural area of the Alentejo, the raising of sheep under the watchful eye of shepherds is common practice. Mutton and lamb are also very popular dishes in the region.

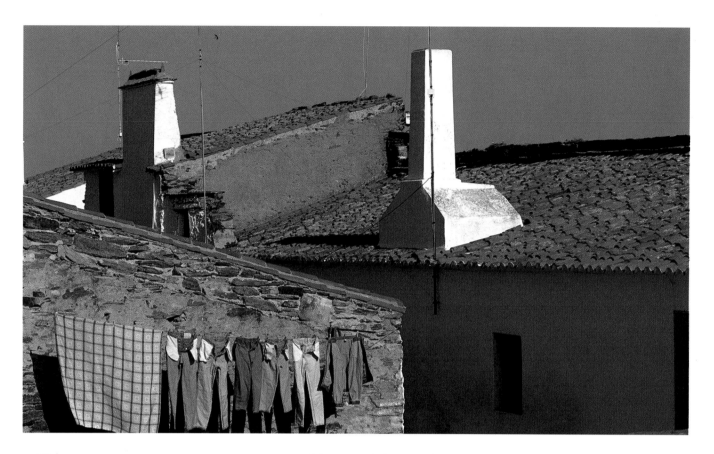

*T*op:
*Monsaraz, an old fortified village
50 kilometres (31 miles) south-east of
Évora, built entirely of schist and
limestone.*
Above:
*Two inhabitants of Monsaraz in
traditional costume.*
Opposite:
*'Mértola': storks, which have settled
in the Alentejo, nesting on top of
a house.*

set ablaze, and the town's watchtower, the powerful keep built in 1258, stands high and gleaming on its hilltop. Of the five centuries of Moorish occupation, the old town preserves the typical oriental architecture with its low houses grouped around narrow streets, and some houses, with patio-like courtyards, perpetuate an ancient lifestyle soaked in Arabo-Andalusian culture. But it is especially at Évora that the cultural heritage of the Alentejo, enriched by various civilizations during antiquity and the Middle Ages, is concentrated at its most forceful, burning with its brightest flame.

Évora is a real treasure in the heart of the Alentejo. All the roads travelled by the Romans, the Arab conquerors, and later, in the seventeenth century, the Spaniards, seemed to have met here. During the Catholic reconquest it was both a bridgehead and a strategic prize sought by both sides. With its 45,000 or so inhabitants, it is the capital of the province of Upper Alentejo. One of the oldest foundations of the Iberian Peninsula, it was known in Roman days as

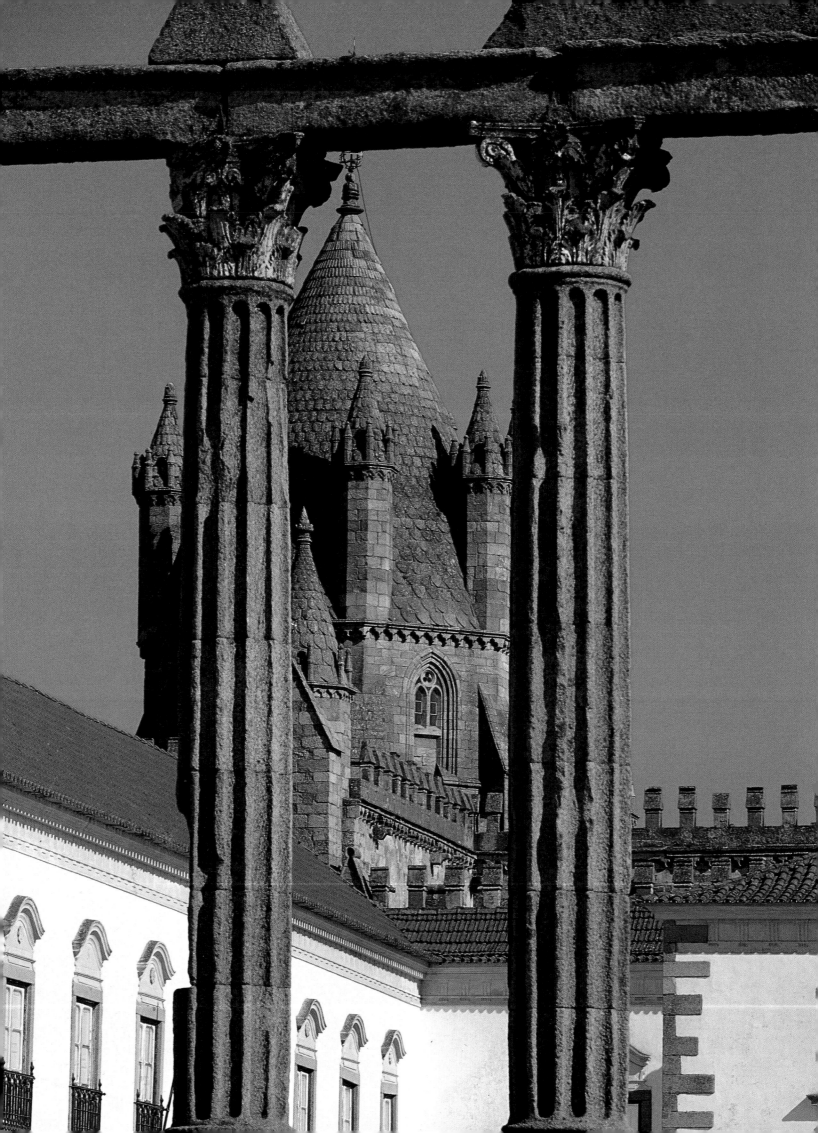

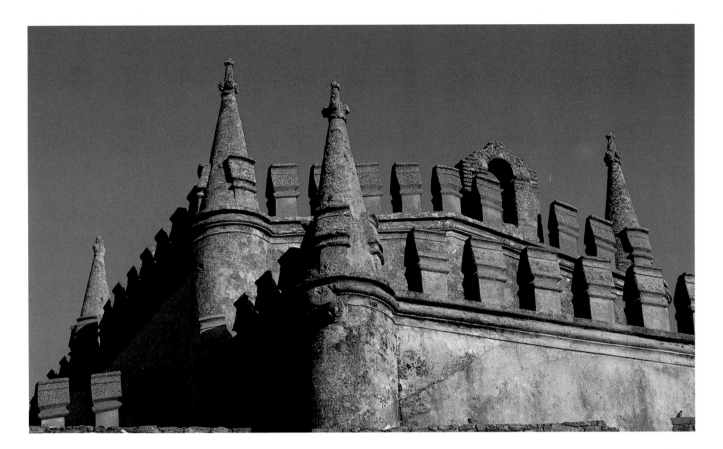

Liberalitas Iulia. Recaptured from the Moors in 1165 by a Christian knight, it became the second most important city in the kingdom after Lisbon from the fourteenth to the sixteenth centuries. This was the era in which sculpture, painting, and the *mudéjar* architectural decoration inspired by the work of Arabo-Andalusian artisans developed on such a scale and to such perfection that they long remained the pride of the Court and the glory of Portugal. Listed as a World Heritage Site by UNESCO, Évora is truly unique. It has managed to preserve in excellent condition the remains of its Roman buildings, the oriental charm of its historic centre, and the rest of its varied but harmonious architecture. All is contained within what survives of the various walls: the 'Vauban' and Romano-Gothic fortifications, as well as structures dating from the time of Fernando I. As a result, the prestige of this fine city continues to shed its light on the whole of southern Portugal. The cathedral, the Temple of Diana, the Church of the Lóios (São João Evangelista), the Vimioso Palace,

Above: This medieval fortified church near Évora, with its double row of crenellations and air of impregnability, is characteristic of the Alentejo.

Opposite: The Temple of Diana at Évora is one of the most striking vestiges of the Roman era.

Overleaf: Entrance to a delightful 'quinta' (country house) in the region of Elvas, not far from the Spanish border.

Above:
The aqueduct at Elvas is the pride
of the town. Built at the beginning
of the sixteenth century, it is
8 kilometres (5 miles) long,
30 metres (98ft) high, and
carried on nearly 850 arches.
Opposite: Cloisters in the Alentejo:
the style is very restrained.

the five-cornered tower of the medieval castle, or even the public library, are all buildings with different purposes yet happily sharing space in the heart of Évora, which has been justly nick-named Portugal's 'museum-city'.

Two hundred kilometres (125 miles) south-west of Lisbon, the Serra de Caldeirão begins to pick up height. Then the landscape seesaws – one's awareness is suddenly dominated by the Algarve. Relief, soil, vegetation, and climate all undergo a simultaneous transformation. From the River Guadiana, which marks the Spanish border, as far as Sagres, the ancient city at the westernmost point of the Algarve, where Henry the Navigator founded a school of navigation to prepare for the great sixteenth-century voyages, the coastline of Portugal's most southerly province extends for 150 kilometres (94 miles). The Algarve – from the Arabic Al-Gharb meaning 'West' – was the last area to be retaken from the Moors by the king of Portugal in 1292, and it still bears the imprint of the

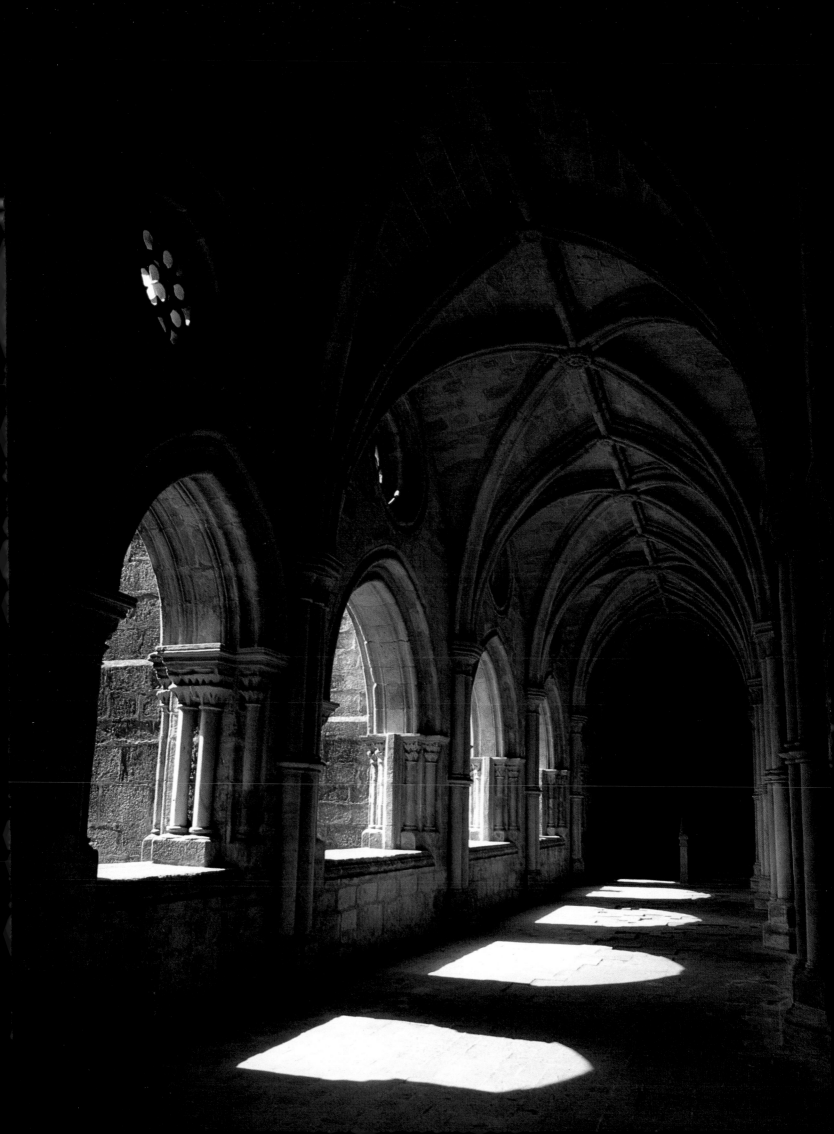

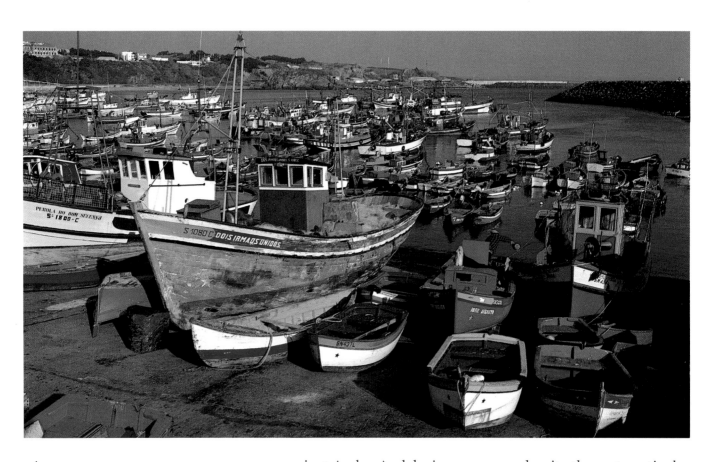

*A*bove:
Albufeira harbour.
Opposite:
The reds, yellows, and greens of
fishing boats drawn up on the fine,
golden sand of a beach at Albufeira
add further gaiety to this already
colourful part of the Algarve.
Overleaf:
A rugged stretch of coastline at Ponta
da Piedade in the Algarve.

ancient Arabo-Andalusian presence, despite the systematic de-struction which occurred during the recapture of the magnificent Moslem strongholds. The best example is Silves. For all the urban setting, its terraces, intricate architectural decoration, and white-washed houses have a definite whiff of the East. This idiosyncratic style, but most of all its fine, carefully tended beaches, its coves and cliffs, its sun which seems immovably fixed in a brilliant blue sky, and its golf courses – frequently associated with big hotels or pres-tigious holiday clubs – make the Algarve a Mecca for tourists. Clustered around Faro are resort towns like Albufeira, famous for its small bays nestling between massive cliffs; Olhão, which pro-tects fine lagoons rich in wildlife; and the wealthy community of Loulé, with its ostentatious villas. Together, places such as these attract hundreds of thousands of visitors a year.

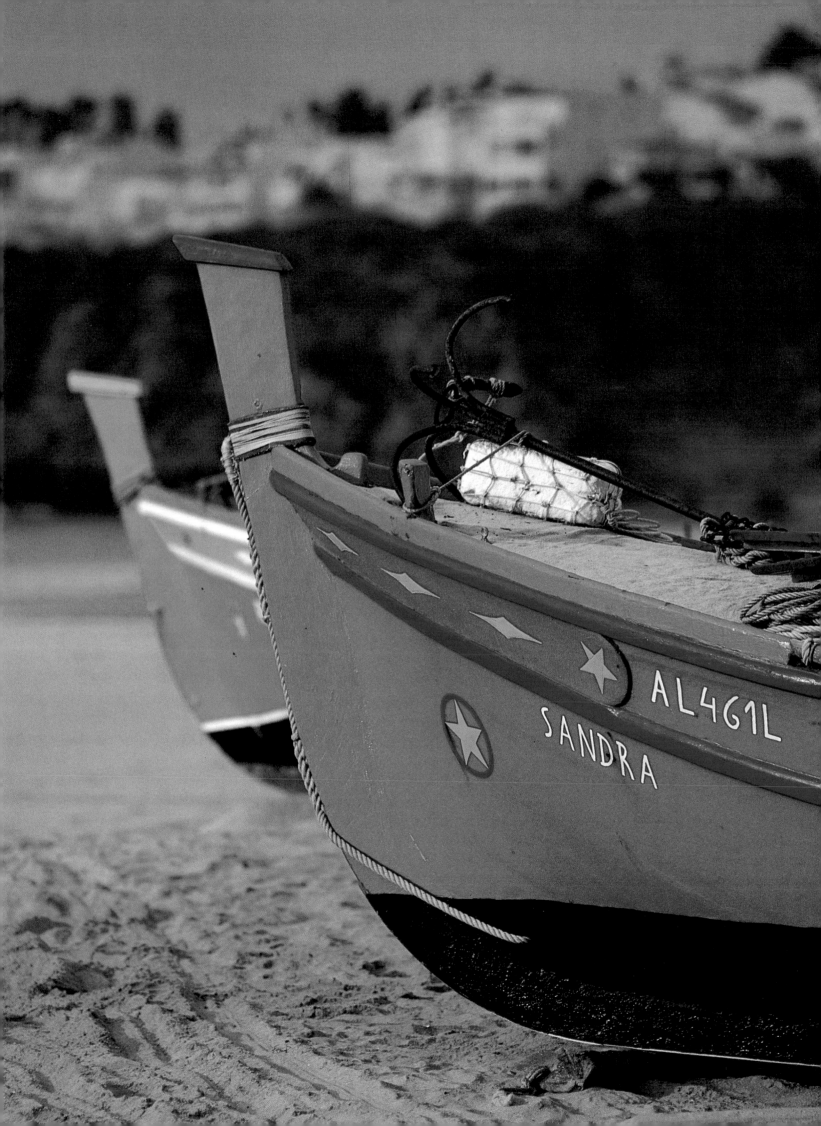

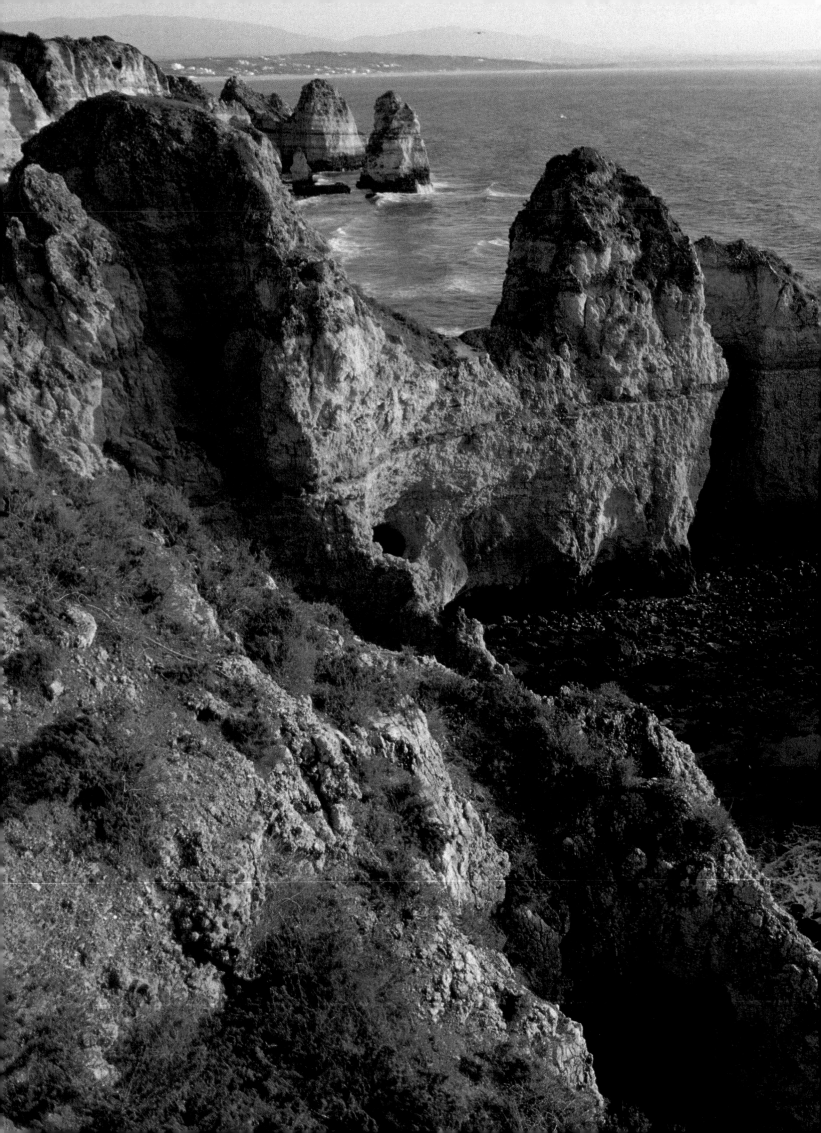

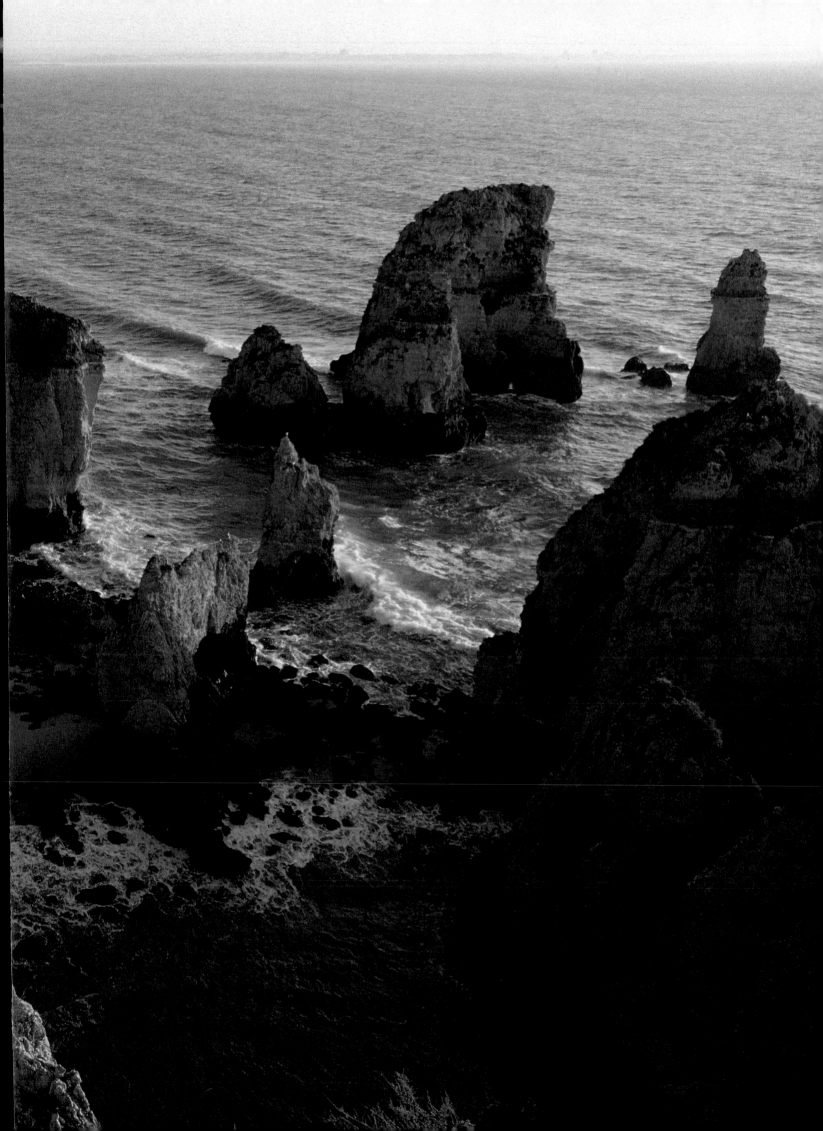

USEFUL INFORMATION

INFORMATION BUREAU: Portuguese National Tourist Office, 22 Sackville Street, London W1X 1DE; tel. 0171 494 1441, fax 0171 494 1868.

TOURIST INFORMATION IN PORTUGAL: Posto de Turismo, Palácio Foz, Praça dos Restauradores, 1200 Lisboa; tel. 01-346 3643, fax 01-346 8772. There are tourist information offices in all the main towns and cities; at Lisbon, Porto, and Faro airports; and at the principal border crossings.

ENTRY FORMALITIES: A valid passport is all you need; UK citizens do not require visas.

PORTUGUESE EMBASSY: 11 Belgrave Square, London SW1X 8PP; tel. 0171 235 5331; fax 0171 245 1287.

PORTUGUESE CONSULATE: 62 Brompton Road, London SW3 1BJ; tel. 0171 581 8722; fax 0171 581 3085.

BRITISH EMBASSY AND CONSULATE IN PORTUGAL: Rua de São Bernardo No 33, 1200 Lisboa. Embassy: tel. 01-292 4000, fax 01-292 4185. Consulate: 01-392 4159; fax 01-392 4188.

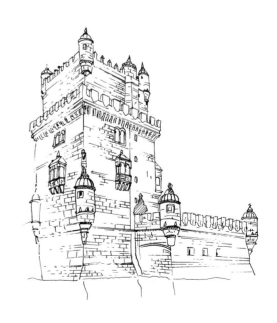

CURRENCY: Portugal's currency is the escudo (abbreviated to $, PTE or Esc), divided into 100 centavos; there were 290 escudos to the pound in February 1999. Prices are written with the escudo sign in the middle where the decimal point would be in other currencies (eg 1$50). The euro became the unit of currency for non-cash transactions on 1 January 1999, and will replace the escudo completely on 30 June 2002.

There are large numbers of Multibanco cashpoint machines around the country, and all major credit cards including Visa, Mastercard, American Express, and Diners Card are accepted.

GETTING TO PORTUGAL: The national airline is TAP Air Portugal (38 Gillingham Street, London SW1V 1JW; tel. 0171 828 0262, fax 0171 828 1742), which operates daily flights from London Heathrow to Lisbon, Porto, and Faro. British Airways also serves all three destinations, and Iberia flies to Lisbon and Faro. Most charter flights go to Faro. If you are in less of a hurry, the journey by train from London Waterloo to Lisbon via Paris takes just over 24 hours.

THE COUNTRY AND THE PEOPLE

GEOGRAPHY: Portugal is located at the south-westernmost tip of Europe. It is roughly rectangular, with 800 km (500 miles) of Atlantic coastline running from north to south, and is only 220 km (140 miles) wide at its widest point from west to east. The country borders Spain to the north and east, and rises from the south-west to the northeast. The river Tagus, which flows from Spain diagonally across Portugal to the coast near Lisbon, divides the country into two very distinct halves. The mountainous northern region is green, fertile, and dominated by vineyards, and this is where most of the great stately homes and churches are located. The south is flatter, drier, and comparatively infertile, and is used for growing products such as olives and cork. The Algarve (from the Arabic *Al-gharb*, the West) has a milder, wetter climate and almonds, vines, and citrus fruits are grown here. Portugal's highest point is the Torre mountain in the Serra da Estrêla ("Star Mountains"), at 1,993 metres (6,539 feet).

AREA: Mainland Portugal is 89,000 km² (35,000 sq. miles) in area, slightly larger than Great Britain. The country's total area including Madeira and the Azores is just under 100,000 km² (40,000 sq. miles).

CAPITAL: Lisbon. The city itself has a population of 700,000, but the surrounding conurbation is home to around 2 million people.

FORM OF GOVERNMENT: Portugal has been a republic since 1974, and is a parliamentary democracy. A new constitution was introduced in 1976.

ECONOMY: Portugal used to be a poor agricultural nation with high unemployment, but its situation has greatly improved since it joined the European Community in 1986. Its main exports include cork (where it produces 50% of total world output), wine, sardines, timber, cellulose, resins, and textiles.

CLIMATE: Portugal can broadly be divided into three climatic zones. In the mountainous northeast, the climate is continental with relatively cold winters and hot summers. The climate of the northwest is moderated by the Atlantic, and is fairly wet. The Algarve in the south has a mild Mediterranean climate year-round.

LOCAL TIME: GMT.

POPULATION: Mainland Portugal has a population of around 10 million, with a further 500,000 living in Madeira and the Azores.

RELIGION: 95% Catholic.

LANGUAGE: Portuguese, which is spoken by 135 million people worldwide, most of them in Brazil.

TOURIST ATTRACTIONS: LISBON, the capital, is one of the world's most beautiful cities. Like Rome, it is built on seven hills. Much of it was devasted by an earthquake in 1755, though the old fishermen's quarter of CHIADO and THE BAIRO ALTO were largely spared. Today, the SANTA JUSTA elevator links Alfama with the rebuilt new city (LA BAIXA) below. Lisbon's trademark, the BELÉM TOWER, is located to the west on the Tagus along with the JERÓNIMOS MONASTERY. Both buildings were constructed in the seventeenth century in the Manuelian style, and are now a UNESCO world heritage site.

Don't miss the world's only TILE MUSEUM, with its collection of the blue azulejo tiles that are such a distinctive feature of Portugal. They were used to build Lisbon's most beautiful church, the IGREJA DE SÃO ROQUE.

One good way to visit is using the Lisboa Card, which includes free travel on all of Lisbon's public transport and entrance to 26 museums, monuments and sights.

The former royal summer residence of QUELUZ is sited about 15 km (10 miles) to the west of the capital. This ornate rococo building is now designated as a national palace, and is used for state receptions. A few kilometres on towards the coast is the town of SINTRA, another world heritage site, a place of elegant palaces and some of the most luxuriant vegetation in Europe.

The nearby town of MAFRA is dominated by its palace-convent, Portugal's most monumental building. The huge site comprises a basilica, a monastery, a royal palace and a vast library of priceless books.

The spectacular Gothic BATALHA (BATTLE) ABBEY, near Leiria, was built in commemoration of a fourteenth-century military victory over Spain. The elaborate stone grilles of its Claustro Real, or Royal Cloister, are a masterpiece of Manueline architecture.

Another of Portugal's most important buildings is the CONVENTO DE CRISTO in the town of TOMAR. This was built between the twelfth and seventeenth centuries, and is particularly famous for its Manueline windows with maritime motifs.

Medieval COIMBRA, the former capital of Portugal, is the home of one of Europe's oldest universities. CONÍMBRIGA is the site of some important Roman excavations which have revealed a number of magnificent mosaic floors.

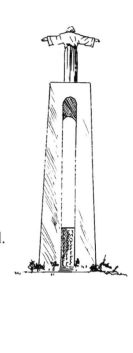

PORTO, in the north, is the cradle of Portugal: its oldest city, and the origin of the country's name. The 75-metre (247-feet) church tower of SÃO PEDRO DOS CLÉRIGOS provides a memorable view across the city, and a visit to the port wine lodges on the other side of the Douro is an absolute must.

BRAGA is the capital of the province of Minho and the religious centre of Portugal. The nearby great eighteenth-century stairway and church of BOM JESUS DO MONTE is an important place of pilgrimage. The Renaissance monastery at AMARANTE is beautifully decorated with seventeenth-century azulejo tiles.

Portugal's first king, Afonso Henriques, was born in GUIMARÃES, and the town has a very well preserved historic centre. ÉVORA, in the southern province of Alentejo, is another world heritage site. The town is a museum of architecture in its own right, with countless important buildings from the different periods of Portuguese history. The best-known is the Roman TEMPLE OF DIANA, dating from the second and third centuries. The fortified town of ESTREMOZ has many of the whitewashed houses that are so typical of the south. Near the Spanish border is MONSARAZ a frontier fortress once ruled by the Knights Templar. The 8-kilometre (5-mile) aqueduct of ELVAS is not far away.

The Algarve has the country's finest beaches. This coastal strip was the last part of Portgual to be won back from the Moors, in 1292, after centuries of foreign rule. And SAGRES, at the far south-western tip of the country, is where Henry the Navigator founded his famous school for seafarers nearly 600 years ago.

TRANSPORT: There are regular buses between all the main towns and cities, as well as the larger villages; these also stop at railway stations to connect with trains. Express buses cover the most important tourist routes, with tickets being sold in bus stations in larger towns and cities.

The Portuguese railway company CP (Caminhos de Ferro Portugueses) operates an extensive network of cheap and comfortable express trains, as well as intercity trains on the main routes. Tourist tickets allowing unlimited mileage on all trains for one, two, or three weeks start at 18,000 escudos.

The Portuguese airline, TAP, operates scheduled and charter services between Lisbon, Porto, and Faro. If you can cope with the hair-raising style of driving and wish to hire a car, you will need to be 21 or over, and have ID and a valid driving licence. A green card is compulsory, and fully comprehensive insurance is recommended. Tolls are payable on motorways.

PORTUGUESE CUISINE: The food in Portugal is as varied as the landscape. Much of the diet of the Algarve is based on fish and seafood, while further inland, dishes worth trying include lamb stew and crispy suckling pig. *Bacalhau*, dried salt cod, is a hugely versatile staple dish, while the national dish, *caldo verde*, is a cabbage and potato broth served with smoked sausage. While based on simple rural cuisine, the food has been distinctly piquant since Portuguese seafarers started to bring back spices from their voyages of discovery. Drinks are equally varied; they include the famous *vinho verde*, a low-alcohol sparkling wine best drunk chilled, and of course port from Porto. There are umpteen different versions of coffee, which is nearly always drunk with sugar.

Although all information was carefully checked at the time of going to press (February 1999), the publisher cannot accept any responsibility for its accuracy.